BEAUTY
AND THE
BEASTS

THE HIDDEN WORLD
OF WILDFLOWERS

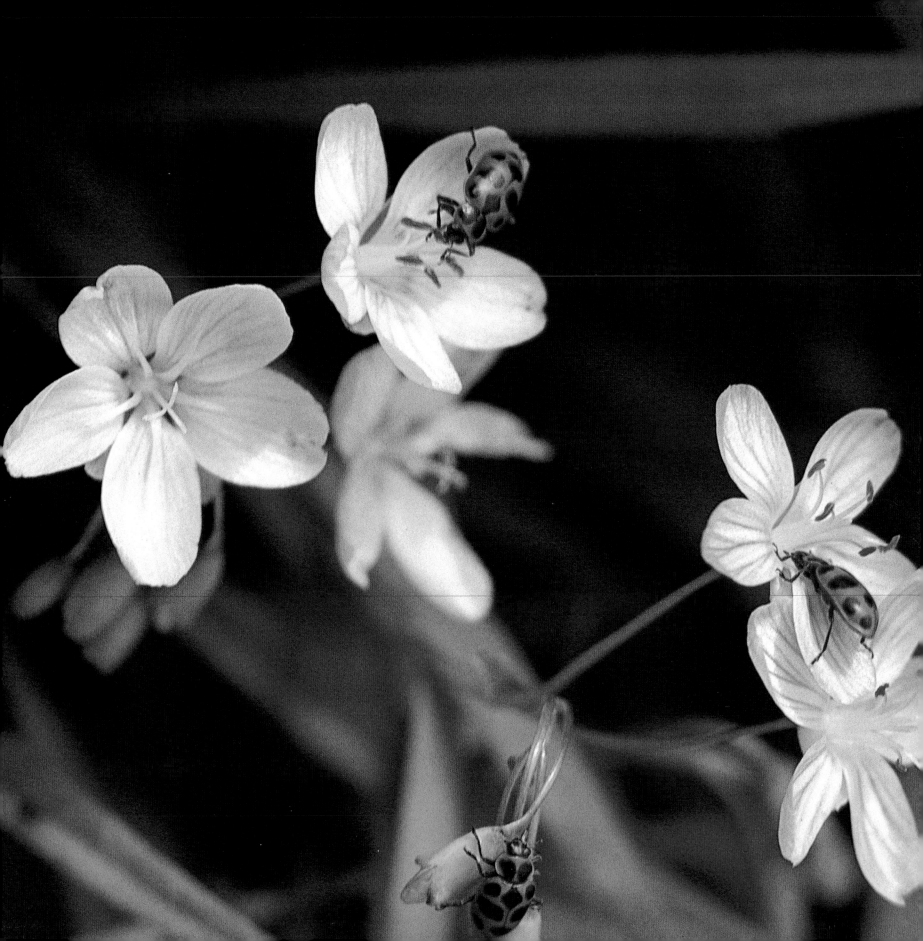

BEAUTY
AND THE
BEASTS

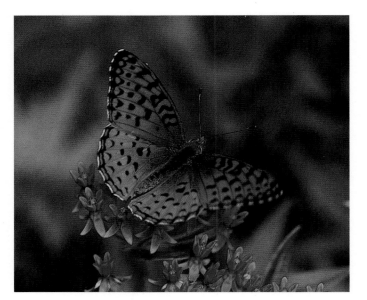

THE HIDDEN WORLD
OF WILDFLOWERS

Michael W. P. Runtz

Stoddart

A BOSTON MILLS PRESS BOOK

Canadian Cataloguing in Publication Data

Runtz, Michael W. P.
 Beauty and the Beasts: the hidden world of
wildflowers

Includes bibliographical references.
ISBN 1–55046–106–0

1. Wild flowers. 2. Wild flowers – Pictorial works.
I. Title

QK85.5R85 1994 582.13 C94–930281–3

Cover background: Wood-betony, Pedicularis canadensis.
Cover inset: A primrose moth, Schinia florida, *on evening-primrose,*
Oenothera biennis.

Title page: Spotted ladybird beetles, Coleomegilla fuscilabris,
on Virginian spring-beauties, Claytonia virginica.
An aphrodite fritillary, Speyeria aphrodite, *on butterfly-weed,*
Asclepias tuberosa.

First published in 1994 by
Stoddart Publishing Co. Limited
34 Lesmill Road
Toronto, Canada
M3B 2T6
(416) 445-3333

A BOSTON MILLS PRESS BOOK
The Boston Mills Press
132 Main St.
Erin, Ontario
N0B 1T0

Design by Andrew Smith

Copy-editing by Heather Lang-Runtz

Page composition by Andrew Smith Graphics Inc.

Printed in Hong Kong by Book Art Inc., Toronto

The publisher gratefully acknowledges the support of the Canada
Council, Ontario Ministry of Culture and Communications,
Ontario Arts Council, and Ontario Publishing Centre in the
development of writing and publishing in Canada.

To Heather,
for appreciating, instructing, tolerating, understanding,
and supporting always.

Wildflowers frequently put on breathtaking displays in spectacular places. Here a mixture of cardinal-flower, Lobelia cardinalis; joe-pye weed, Eupatorium maculatum; grass-leaved goldenrod, Solidago graminifolia; and boneset, Eupatorium perfoliatum, graces a river's edge.

CONTENTS

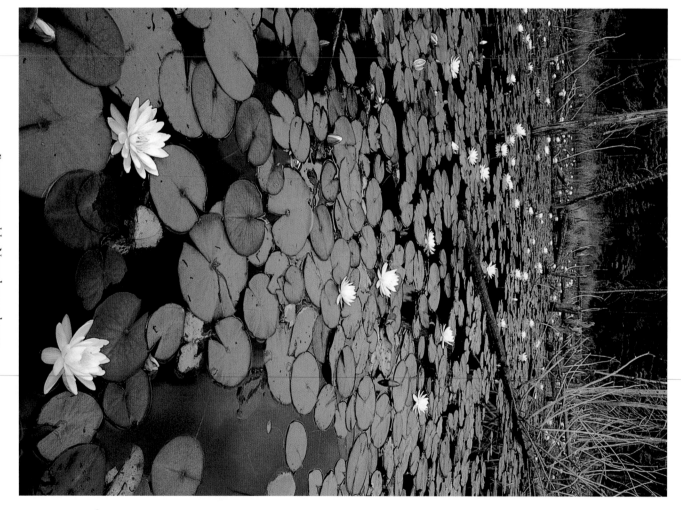

Fragrant water-lily, Nymphaea odorata.

ACKNOWLEDGMENTS

There are many rewards to being a naturalist. One of the greatest is the countless talented people one meets along the way. I have been fortunate in having many such individuals generously share with me their passion for and knowledge of wildflowers and other components of the natural world.

It is impossible in this brief space to recognize everyone who over the years has served as tutor or motivator—so lengthy would the list of acknowledgments be. Thus, only the individuals who directly assisted in the creation of this book are mentioned. However, I also offer my deepest gratitude to those not named here.

My sincere thanks to Sean Blaney, Bob Bracken, Dr. J. M. Campbell, Dr. Paul Catling, Dr. B. E. Cooper, Dr. J. M. Cumming, Dr. Hans Damman, Donnie Gordon, Dr. Henri Goulet, Verna McGiffin, Dr. Ted Mosquin, Richard Russell, Sandy (Don) Sutherland, Sheila and Harry Thomson, Dr. J. R. Vockeroth, and Adolf Vogg.

Thanks also to Peter Scarth and Joan Ferguson, of Kodak Canada Inc., for providing Kodak film used in this project; and to Donna Kelly, of Canon Canada Inc., for Canon's support.

Two individuals deserve additional recognition: Peter Burke, an extremely gifted artist and naturalist, for the illustrations that grace the openings to six chapters; and Bill (Dr. W. J.) Crins, for critically reviewing the text and offering invaluable suggestions. Also, Bill, thanks for all your companionship in those "early years" when we spent countless hours bog-trotting and searching for elusive orchids, and for your continuing friendship and botanical tutoring.

And to my wife, Heather, heartfelt appreciation for once again suffering the double frustration of living with (or is it without?) a naturalist and editing his book.

May we all continue to enjoy wildflowers for many years ahead!

Canon

INTRODUCTION

For their beauty and elegance, for their diverse colors and forms, wildflowers are admired and appreciated by virtually everyone. However, very few people make the effort to look beyond these plants' physical charms. This is unfortunate, for there is much more to these delightful entities than first meets the eye.

Underlying their beauty is a truly amazing world of astounding adaptations, irresistible lures, bizarre trickery, and even fatal treachery.

This book is an introduction to this hidden world, not an exhaustive treatment of all facets of wildflower biology. *Beauty and the Beasts: The Hidden World of Wildflowers* is simply an overview of some of the particularly intriguing and important aspects of floral biology.

It is my hope that after reading this book, the next time you encounter a gorgeous bloom, you will appreciate much more than just its outward beauty.

Joe-pye weed, Eupatorium maculatum.

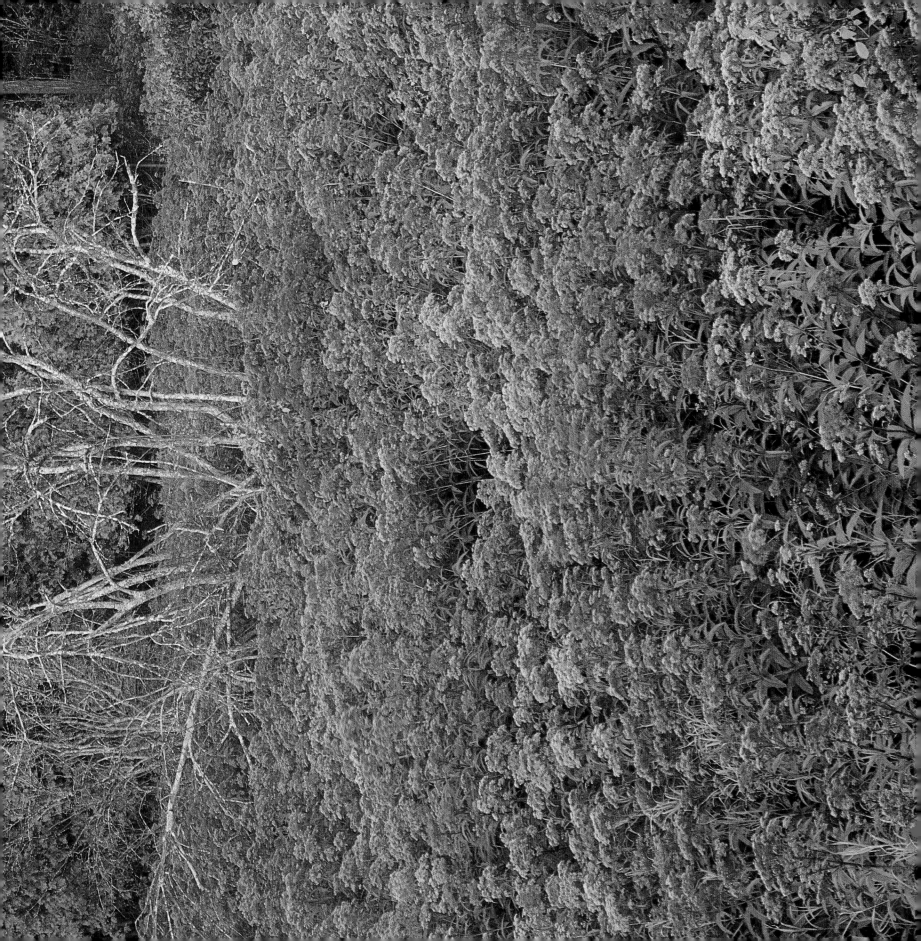

DESIGN OF PERFECTION

"Flowers rank amongst the most beautiful productions of nature; but they have been rendered conspicuous in contrast with the green leaves, and in consequence at the same time beautiful, so that they may be easily observed by insects."

Charles Darwin, *The Origin of Species*, 1859

The incredible beauty of the columbine, Aquilegia canadensis, *and purple clematis,* Clematis occidentalis, *is an obvious reason why we hold wildflowers in such high esteem.*

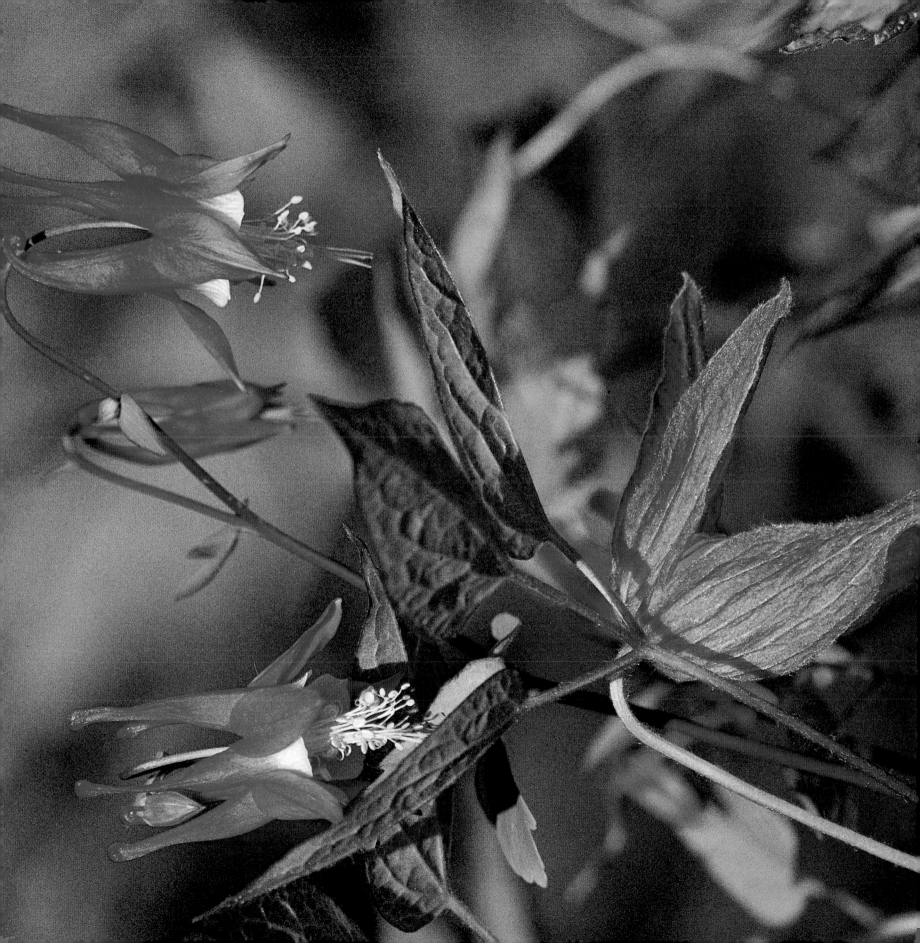

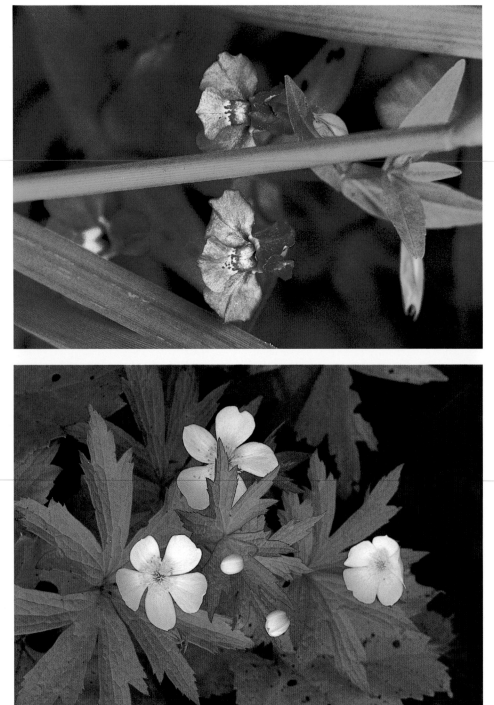

Wildflowers exhibit an endless array of color and form. Monkeyflower, Mimulus ringens (left). Canada anemone, Anemone canadensis (right).

WILDFLOWERS. IF THIS WORD CONJURES UP PLEASING IMAGES of colorful forms, you are not alone. Our species has long been fascinated with their appearance, and scores of books have been dedicated to their identification and visual splendor.

However, the things that we call wildflowers are really not at all a well-defined botanical group. In fact, the term does not even appear in the Oxford dictionary. Other references define them as wild plants that produce flowering parts. However, once held up to scrutiny, the broad definition soon falls apart. Grasses and sedges—each a major group of wild flowering plants—are not classified as wildflowers, for they generally produce inconspicuous (yet, at times, elaborate) flowers. Many trees also produce highly sculptured, ornate blooms but are not considered wildflowers either.

Thus, we are really quite selective as to what we deem to be a wildflower. While the term refers in general to soft-stemmed plants with showy blooms, wildflower books also include plants with woody stems. These inconsistencies make it virtually impossible to arrive at an all-encompassing definition for every type of plant we call a wildflower.

However vague, the wildflower group displays an astounding array of structural modifications and functions. The most obvious and admired structure is the flower, also known as a bloom or blossom. As the reproductive part of the plant, the flower harbors the female organs (the ovary-bearing pistils) and the male organs (the pollen-producing stamens). In most species of wildflowers, an individual bloom carries both types of sexual organs. There are some species,

however, such as white campion (*Silene pratensis*), in which only one sex is produced.

As is the case for all living organisms, reproduction is a vital process for wildflowers. Because the majority of wildflowers exploit insects and other animals, including birds and even bats, for their pollination, their blooms are usually designed to draw attention. Their bold colors encompass the spectrum visible to us but individually attract only specific visitors. Flower shapes and smells also vary from species to species, providing each with a unique combination of characteristics.

Even the number of blooms per wildflower is a variable. Plants such as white trillium (*Trillium grandiflorum*) bear only a single bloom; others exhibit a cluster of flowers known as an inflorescence. An inflorescence can also appear in a variety of forms, including flat-topped umbels, as in wild parsnip (*Pastinaca sativa*) and Queen Anne's lace (*Daucus carota*), elongate racemes or stalked clusters, as in moth mullein (*Verbascum blattaria*) and fireweed (*Epilobium angustifolium*), and loose spikes, as in shining ladies'-tresses (*Spiranthes lucida*) and purple loosestrife (*Lythrum salicaria*).

In many wildflowers, a bloom contains a single set of petals, sepals, stamens, and pistils. However, in the aster family, Compositae, one of the largest wildflower groups, a number of individual blossoms are grouped together onto a flowerhead that often resembles a single flower. Many of the Compositae, including the ox-eye daisy (*Chrysanthemum leucanthemum*), bear two types of flowers on a flowerhead. In the ox-eye daisy, the white "petals" are actually female flower-bearing structures

known as rays, and the central yellow region a mass of hundreds of bisexual blooms called disk flowers. Those of you who played the childhood game "he (or she) loves me, he (or she) loves me not" might be surprised to learn that instead of a single flower in your hand, you were actually holding an entire bouquet!

With their dazzling colors and almost infinite forms, wildflowers add much to our visual world. As an added bonus, they frequently grow in spectacular sites. But to wildflowers our appreciation of their beauty is inconsequential, for their sole purpose is to reproduce and carry on their individual genetic lines. To achieve this, they must grow successfully from seed in frequently demanding environments, survive a horde of hungry plant consumers, exploit wind, water, or animals for pollination of their flowers, and eventually disperse their progeny to an appropriate habitat. When one considers how many obstacles a wildflower must overcome in order to bloom, one cannot help but be appreciative of more than its attractive appearance. For, without question, each and every one of our wildflowers is truly much more than just another pretty face!

Because grasses, such as Canada blue-joint, Calamagrostis canadensis (above), and sedges usually do not produce showy blooms, they are not considered to be wildflowers.

DESIGN OF PERFECTION

The spectacular blooms of trees such as red pine, Pinus resinosa (below left), and tuliptree, Liriodendron tulipifera (below right), rival the beauty offered by any wildflower.

White trillium, Trillium grandiflorum (bottom left), and bloodroot, Sanguinaria canadensis (bottom right), produce single blooms.

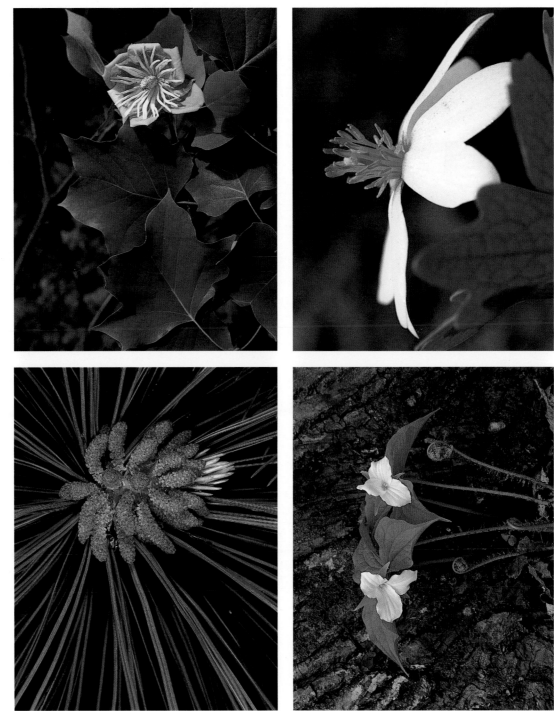

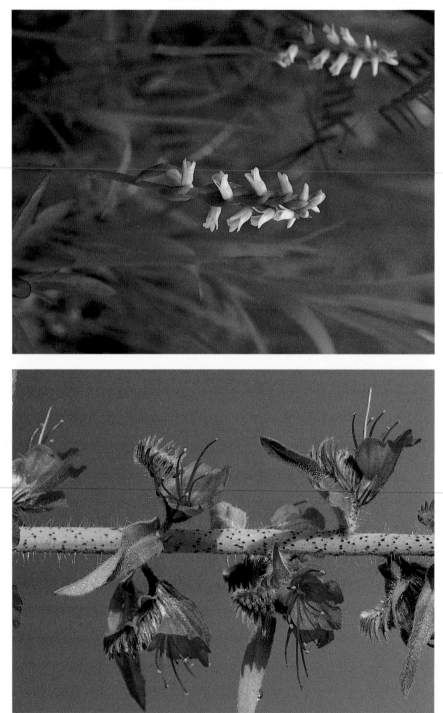

BEAUTY AND THE BEASTS

Shining ladies'-tresses, Spiranthes lucida, displays a spike of stalkless flowers (above left). Blue-weed, Echium vulgare, produces racemes, groups of stalked flowers attached to a central stem (above right). The flat-topped inflorescence of Queen Anne's lace, Daucus carota (opposite), is called an umbel.

18

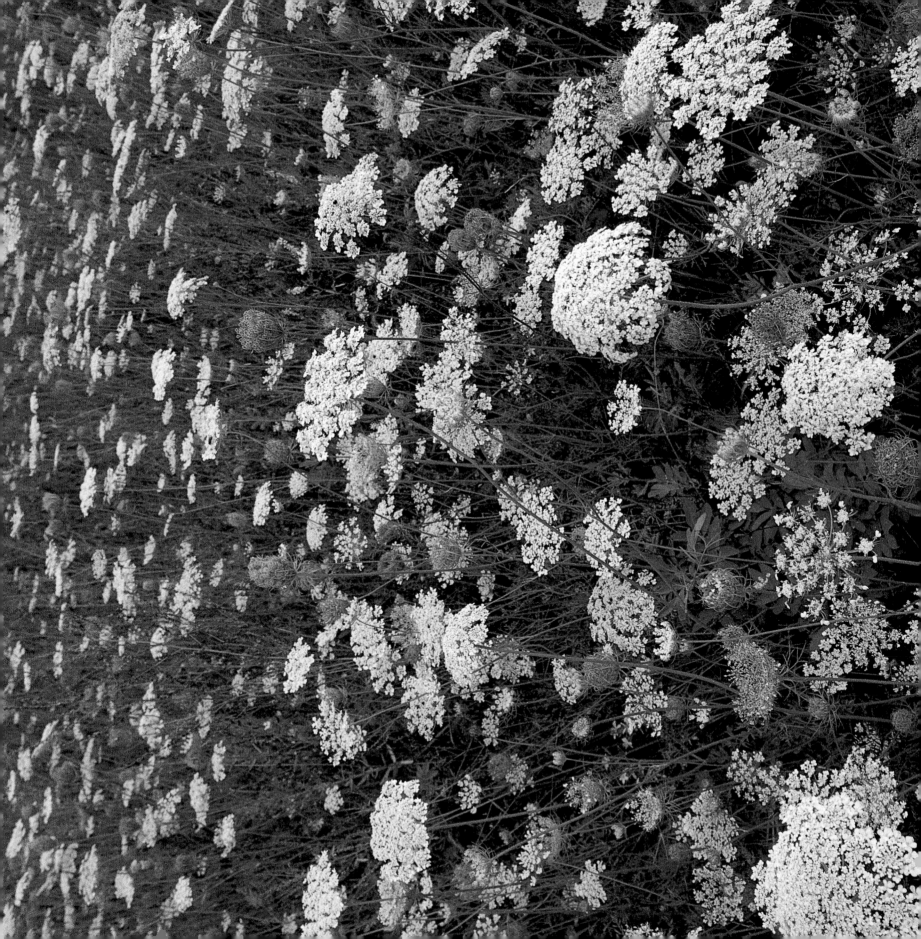

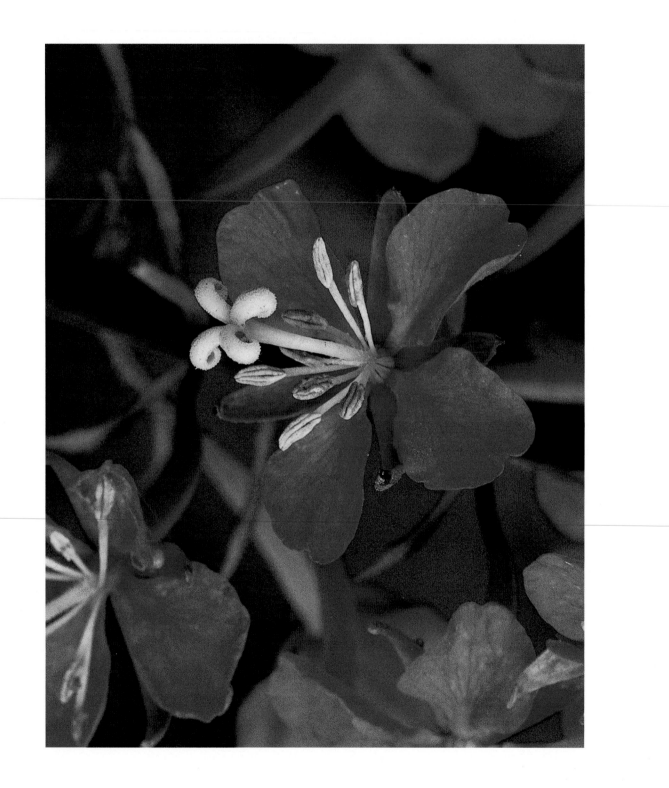

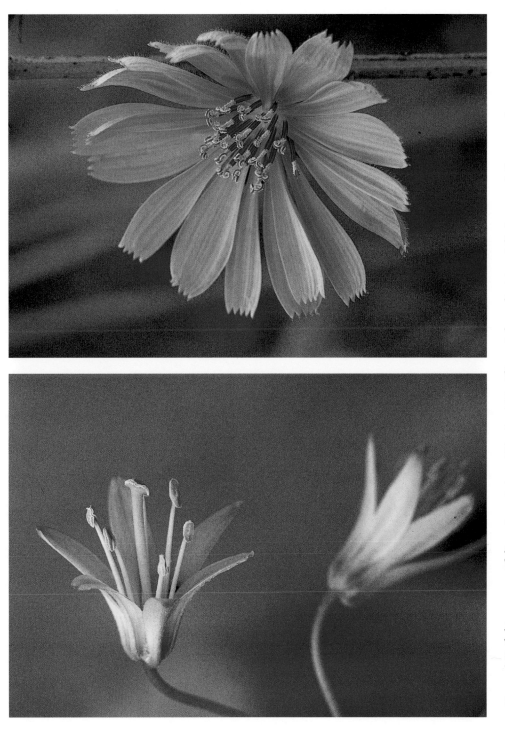

Fireweed, Epilobium angustifolium (opposite), and blue-bead lily, Clintonia borealis (above left), have simple flowers, with numerous stamens clustered around a central pistil. Chicory, Cichorium intybus, bears flowerheads that contain a number of individual flowers grouped together (above right). The apparent "petals" are also compound structures formed by the fusion of five petals.

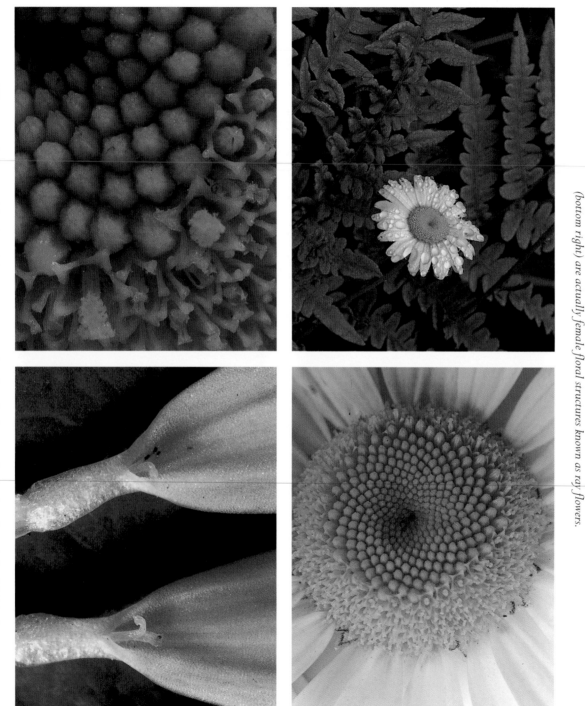

Ox-eye daisy, Chrysanthemum leucanthemum, also bears a composite flowerhead (below left). The central yellow region of the daisy (below right) consists of bisexual disk flowers. A close-up of the disk flowers (bottom left), which upon opening first project stamens. The daisy's white "petals" (bottom right) are actually female floral structures known as ray flowers.

Wildflowers may be renowned for their elaborate appearances, but they also live complex lives. Both ram's-head lady's-slipper, Cypripedium arietinum, and fringed polygala, Polygala paucifolia, interact intricately with insect visitors (opposite).

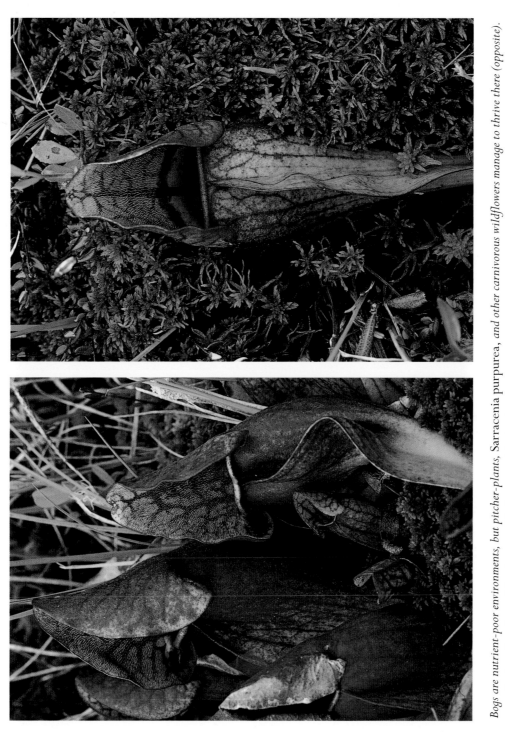

Bogs are nutrient-poor environments, but pitcher-plants, Sarracenia purpurea, and other carnivorous wildflowers manage to thrive there (opposite). Pitcher-plant leaves (above) are modified into vaselike death traps. Lured by scents and guiding patterns, insects enter the plant's open top. Downward-directed hairs ensure that the prey keeps moving lower into the leaf. After sliding down a hairless, slippery section, the insect drowns in water held by the closed leaf.

EVERY HABITAT, WHETHER A NORTHERN WETLAND, TEMPERATE forest, or sun-drenched desert, presents distinct obstacles to the survival of plants. Nutrient deficiency, temperature extremes, and lack of sunlight are a few of the many adversities that wildflowers must overcome if they are to produce flowering parts and, ultimately, viable seeds.

However, for each problem encountered, wildflowers rarely depend on a single solution or device for their survival, employing instead an array of at times astounding adaptations. In this chapter's introductory illustration, greater bladderwort (*Utricularia vulgaris*) has resolved a nutrient problem in ingenious fashion.

As with all life forms, wildflowers need nutrients to survive. Nitrogen, phosphorus, and potassium are essential for healthy plant growth, but in certain environments, such as acidic northern wetlands, they may be in low supply. In particular, the cold floating mats of northern bogs and fens are inhospitable to many wildflowers. Yet, partly because of their incredible adaptations and partly due to a lack of competition from other plants less well adapted, carnivorous wildflowers are quite plentiful.

In these hostile places, bladderworts are able to extract from animals at least a portion of the nutrients they require. With hundreds—in some cases thousands—of underwater leaf traps, they capture countless tiny organisms. From these decaying corpses are gleaned mineral components critical to the bladderwort's survival.

Pitcher-plants (*Sarracenia purpurea*) and several species of

sundews (*Drosera*) also inhabit these trying environments. These carnivorous wildflowers have modified leaves that serve as traps for unsuspecting insects and other small animals, such as water fleas. While the leaves of bladderwort are found either underwater or in moist soil, the leaves of the pitcher-plant and sundew are located above ground.

Pitcher-plant leaves are shaped like a vase and have a protruding lobe at the open top. Bold, wine-colored patterns and nectar secretions along the margins of the lobe are the lures used to attract insects. Once a visitor lands and begins to explore the lobe, downward-directed hairs encourage it to enter the vase. Suddenly the hairy surface transforms into a smooth, waxy slide—and down the insect plunges. The descent is short-lived, however, for the hollow leaf holds an ample supply of water collected from previous rains. The insect eventually drowns, and its body is broken down by enzymes secreted by the plant and by bacteria in the water. The vital elements freed from the decomposing victim are now absorbed by the interior surface of the leaf.

Although the death traps in sundews are much smaller—occasionally even tinier than your little fingernail—they are equally effective. The tiny leaves may be round, oval, or thread-like, depending on the species. The traps, numerous stalked glands, rise up from the leaf surface. Frequently reddish in color, these glands entice insects with their bright appearance and sweet secretions. Insects landing on the glands fail to reap any reward, however, for they quickly become mired in the sticky fluid. Struggling is futile; even the slightest movement

causes the insect to become more entangled. Slowly, the outer stalks bend inward, pressing their victim against the shorter digestive glands located in the central part of the leaf. In some species, the leaf may actually fold over, enclosing the prisoner in its fatal embrace. As the enzymes dissolve the insect, the nutrients are absorbed by the leaf.

Carnivorous wildflowers are not confined solely to our northern wetlands. Many habitats, including shallow marshes and dry savannahs, are also deficient in nutrients. Carnivorous plants can also be found in these habitats, for their ability to extract essential nutrients from living sources allows them to thrive where other wildflowers fail.

Although carnivorous wildflowers are successful in sur-

viving in nutrient-poor sites, other wildflowers can be found here as well. For many of these non-carnivorous plants, a successful strategy has been to employ fungal alliances in expanding the area of nutrient uptake. Known as mycorrhizal associations, these alliances involve fungus interaction with the roots of the wildflower. Although these associations vary, in most cases the fungus actually penetrates the root cells (an endomycorrhizal association). The fungal strands spread through the soil, pulling in nutrients such as nitrogen and phosphorus, and in some cases converting them from unusable complexes into forms that can be readily used by the plant. Naturally, no partnership is complete without a payback. In return, the fungus derives sugars and other organic products from the wildflower.

Heath plants such as sheep laurel, Kalmia angustifolia, dominate northern wetlands, primarily because of fungal partnerships (above left). Because nutrients are in low supply in bogs, Labrador tea, Ledum groenlandicum, retains its leaves all year (above right).

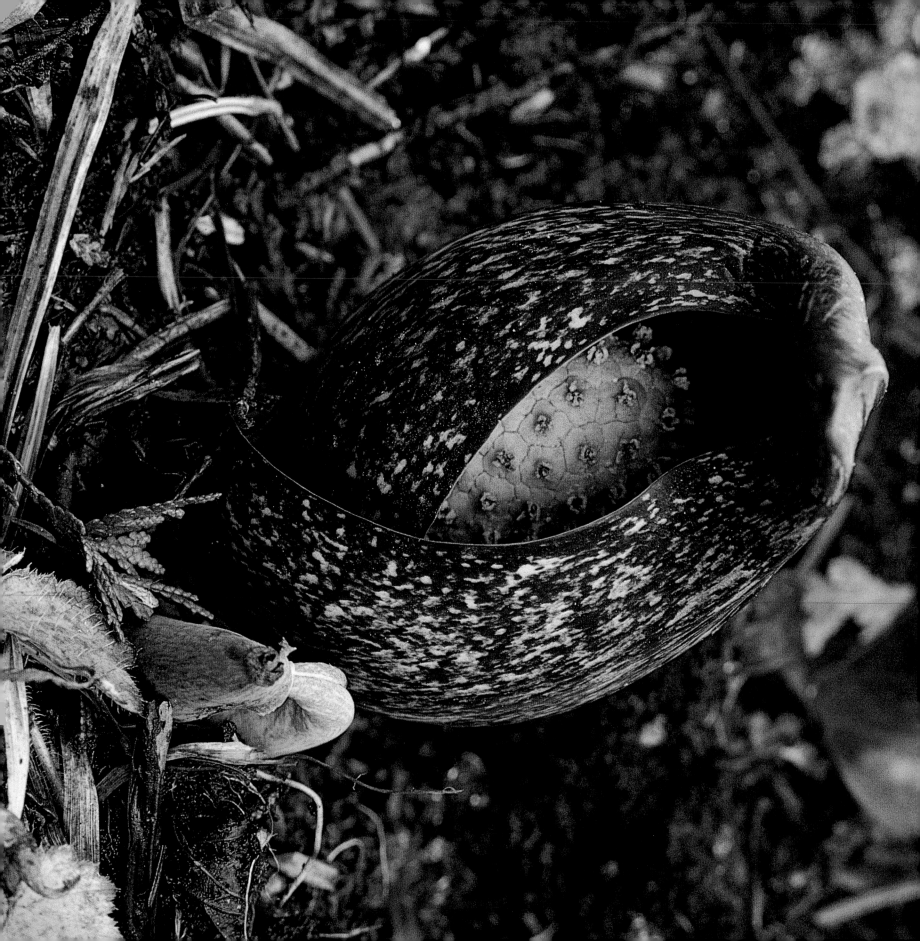

BEATING THE ODDS

Skunk-cabbage, Symplocarpus foetidus, blooms in early spring, often before the snow is gone (opposite). By respiring like an animal, it maintains internal temperatures of over 20 degrees Celsius (68 degrees Fahrenheit). As if an internal thermostat were in operation, the rate of respiration increases on cold days and slows on warmer ones. The high temperatures generated by skunk-cabbage not only melt the surrounding snow (below) but, more importantly, protect the internal flower from the cold's damaging effects.

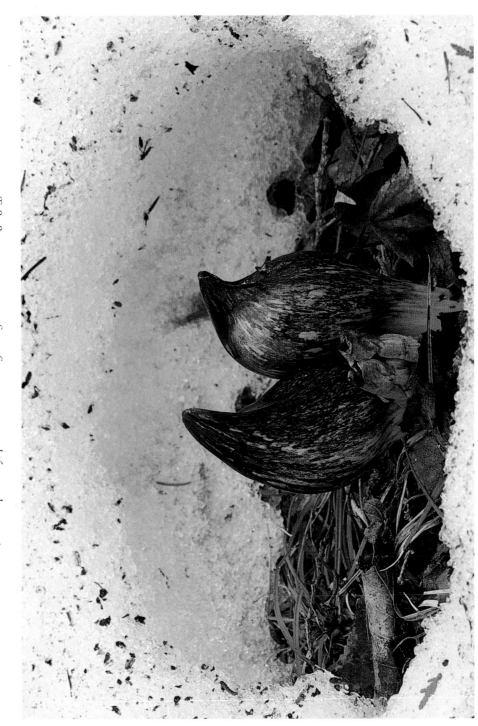

The heath family (Ericaceae) is one of the dominant wildflower groups that thrives in bogs and other northern wetlands because of its fungal relationships. This hardy group includes Labrador tea (*Ledum groenlandicum*), leatherleaf (*Chamaedaphne calyculata*), bog rosemary (*Andromeda glaucophylla*), and sheep laurel (*Kalmia angustifolia*). The fungi that inhabit their roots pick up complex organic nitrogen (unusable by an uninfected plant) and transfer some of this element to the plants in the form of amino acids. In addition to supplying nutrients, the fungi may also benefit the wildflower in other ways. It appears, for example, that mycorrhizae obstruct the uptake of toxic compounds such as aluminum, copper, and zinc, which are prevalent in acidic habitats and are detrimental to many plants. In this way, the fungi actually function as poison-control centers for their wildflower partners.

Ericaceous wildflowers have another feature that helps them to survive the demanding environment of northern regions. By retaining their leaves for more than one year, they hang on to the precious nutrients that would otherwise be lost if their leaves were shed.

Mycorrhizal associations are not unique to the heath family. Wildflowers from many other groups, growing in most habitats, also have fungal partners attached to their roots. While the main advantages of these associations are nutrient and water uptake, there are other benefits, especially for wildflowers that grow in habitats where sunlight is at a premium. Many woodland

Indian pipe, Monotropa uniflora, has lost the need for sunlight because of a mycorrhizal association in its roots (far left). Through a fungal pipeline this parasitic wildflower receives resources stolen from nearby tree roots.

Although all orchids require fungus for germination, some depend on the two-way partnership well past this stage. Striped coralroot, Corallorhiza striata, lives as a saprophyte in dark coniferous forests due to a fungal association in its roots (left).

habitats, for example, contain much larger pools of available nutrients than do bogs. In this environment, nutrients may be plentiful, but wildflowers encounter major survival problems due to lack of sunlight. The shade cast by the trees inhibits the ability of plants to photosynthesize. A few wildflowers are freed from this dependence on sunlight through mycorrhizal associations. Indian pipe (*Monotropa uniflora*) steals nutrients from the roots of nearby trees through its fungal association. By exploiting the food manufactured by other plants, this pallid flower is able to grow in the darkest of habitats.

Even a few orchids have lost the need for sunlight. Coralroots (*Corallorhiza*) are so named because their fungus-infected roots have a knobby appearance not unlike that of coral. These leaf-

less wildflowers generally grow in shade-shrouded woods. While these orchids are deemed saprophytic because much of their nourishment is drawn from decaying plant matter, there is evidence that at least part of the nutrition pulled in by the mycorrhizal fungus is taken from the roots of living trees. Thus, these spectacular plants may, like the Indian pipe, survive as parasites.

Fungal associations are important not only for mature plants but also for wildflower seed germination. The seeds of orchids are unusual because of their size—they are minute, often microscopic—and because they lack food reserves for the developing embryo. To germinate successfully, the seeds must first be infected by specific mycorrhizal fungi that supply the essential nutritional components required for development.

Coralroots, Corallorhiza, are so named because the fungal infestation creates coral-like swellings on their roots (far left).

Spotted coralroot, Corallorhiza maculata, also survives in shade-dominated environments because of a mycorrhizal association (left).

33

Some wildflowers may have lost the need for sunlight because of fungal associations, but others have resolved the shade problem in different ways. Many shade-tolerant wildflowers, such as white baneberry (*Actaea pachypoda*), round-leaved orchid (*Platanthera orbiculata*), blue-bead lily (*Clintonia borealis*), and wild sarsaparilla (*Aralia nudicaulis*), have extremely large leaves. The leaf's large surface area provides a greater region for photosynthesis to occur. Leaf surface area can also be increased by wildflowers producing numerous leaves. Bunchberry (*Cornus canadensis*), partridgeberry (*Mitchella repens*), and wintergreen (*Gaultheria procumbens*), for example, tend to sprawl across the forest floor, thereby conserving the energy required to create an upright stem. This colonial growth pattern is characteristic of plants that survive in coniferous woods, where shade dominates much of the growing season. These plants may also produce a lot of vegetative growth, restricting their flowering to patches of increased light.

Another strategy employed by wildflowers in shady habitats is to prolong the development of their flowering structures. For the first year or so, plants such as Indian cucumber-root (*Medeola virginiana*) do not flower. They merely store energy reserves in underground rootstalks, called rhizomes. When the stored reserves are sufficient, a flowering stalk is produced.

A great number of other wildflowers have defeated the light problem by flowering before shade develops. In our hardwood forests, a rich array of flowers carpets the spring floors from about the beginning of April to the end of May (depending on the latitude). The window for flowering is short, as conditions must be just right for flowering to occur: the soils must be warm enough to promote efficient growth, and sunlight must not be impeded by the leaves of trees. During this period of warmth and prolific light, woodland slopes become alive—briefly—with a colorful profusion of spring ephemerals, including round-lobed hepatica (*Hepatica americana*), white trillium (*Trillium grandiflorum*), spring-beauty (*Claytonia caroliniana* and *Claytonia virginica*), yellow trout-lily (*Erythronium americanum*), and blood-root (*Sanguinaria canadensis*).

Early spring walks through hardwood forests yield some of the most spectacular floral displays. Yet, the flowers that grace this season face risks in appearing at such a fickle time of year. Late frosts and even snowfalls can damage floral parts and also inhibit insect pollinators. Early blooming brings its rewards, but severe hazards lie in abeyance.

While some woodland habitats offer brief periods of unimpeded light, environments such as meadows, prairies, and old fields are relatively sun-drenched year-round. However, even in these open habitats, adjacent plants compete vigorously for available light. In this race for height, wildflowers may grow several times taller than they would in less crowded situations. While this may seem to be of little consequence for the wildflower, the extra resources required to grow taller may

Many wildflowers that grow in hardwood forests beat the shade by blooming early. Carpets of white trillium, Trillium grandiflorum, flowers grace early spring slopes (opposite).

actually lower its success in terms of viable seed production.

In the race for light, a few wildflowers have developed energy conservation strategies. Rather than grow a vigorous stem, some species have elected to exploit the height of other plants growing nearby. Purple vetch (*Vicia cracca*) and wild cucumber (*Echinocystis lobata*), for example, climb other plants with the aid of special grasping leaves called tendrils. Others, such as virgin's-bower (*Clematis virginiana*) and climbing bindweed (*Polygonum scandens*), simply sprawl over other plants. Because these climbing wildflowers depend upon other plants with developed stems, there is a tendency for them to bloom in the summer, after their hosts have developed substantial growth.

Each type of habitat imposes restrictions on the wildflowers that grow there. To counteract the periodic scorching temperatures and drought of the desert, wildflowers such as cacti respond by producing either small or no leaves and

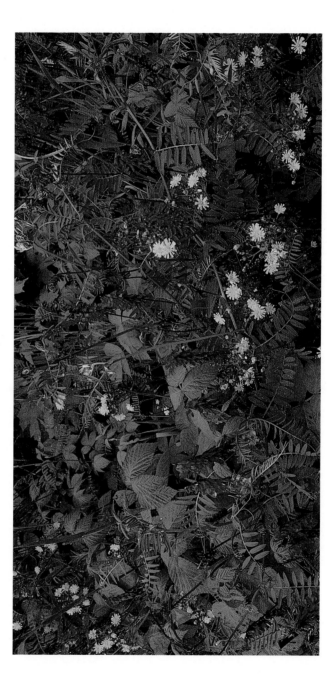

Even in open habitats, a struggle for light exists (above). Some wildflowers, such as purple vetch, Vicia cracca, climb over other plants —here, field hawkweed, Hieracium caespitosum —with the aid of grasping leaves called tendrils.

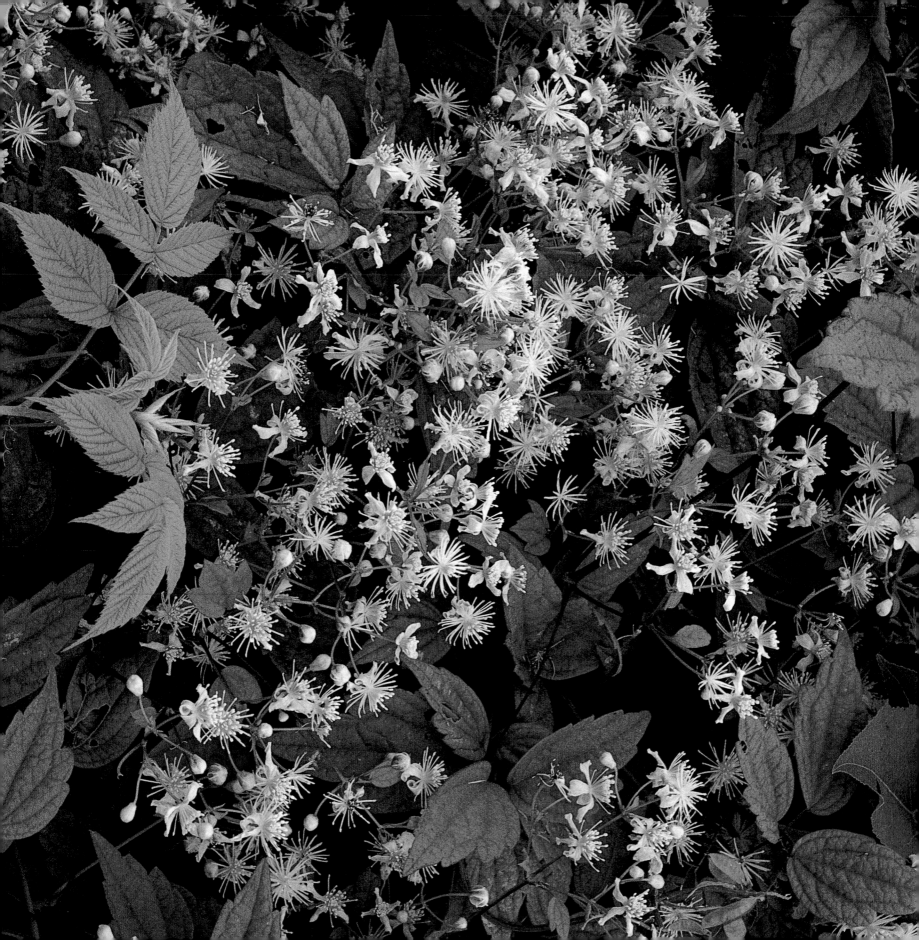

waxy, water-retaining stems. In the Arctic tundra, where cold winds whip across the landscape, northern wildflowers stay very small and frequently develop circular rosettes, with the outer plants offering a windbreak to those growing in the central region. Some northern wildflowers, such as Arctic poppy (*Papaver radicadum*), even track the sun with their flowers. Their blooms act like parabolic reflectors; by trapping heat, they keep their sexual parts warm.

Lack of light, paucity of nutrients, freezing cold, scorching heat—environmental constraints are placed upon wildflowers, no matter where they grow. Yet, wildflowers possess incredible adaptations that allow them to overcome these obstacles in every habitat and at every time of year. And since any single challenge may be conquered by a wide variety of adaptations, a fascinating world of form and function lies waiting, no matter where we roam.

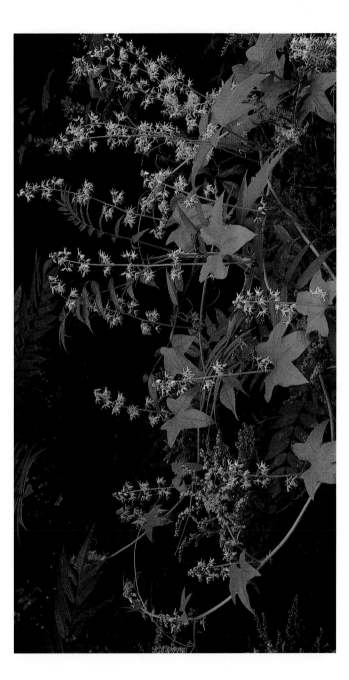

Tendrils are also used by wild cucumber, Echinocystis lobata, to reach elevated perches (above). Not all climbing wildflowers employ tendrils. Virgin's-bower, Clematis virginiana, simply sprawls over other plants (opposite).

41

STAYING ALIVE

W ith a tug of its head, the young white-tailed deer rips another mouthful of leaves from the low shrub. The delectable foliage is quickly chewed and swallowed. Still unsatisfied, the deer reaches out for more. Time after time, the experience is pleasant and browsing continues. Paying no heed to the type of plant on which it is feeding, the inexperienced fawn reaches out yet again. But this time, a different type of plant is inadvertently selected. When the deer pulls its mouth across this plant's stem, sharp pain shoots through its tongue and lips as dozens of spines become embedded in the tender flesh. The young deer jumps back, startled by this nasty experience, then cautiously reapproaches the plant to investigate the cause of such discomfort. The shape, color, and smell of the plant soon burn into the animal's memory. The next time the deer browses, it will be much more discriminating in its menu selection and steer away from the prickly foliage of a bull thistle.

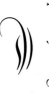

Some wildflowers have developed formidable defenses against their animal marauders. In the case of the strawberry cactus, Echinocereus, defense comes in the form of elaborate spines.

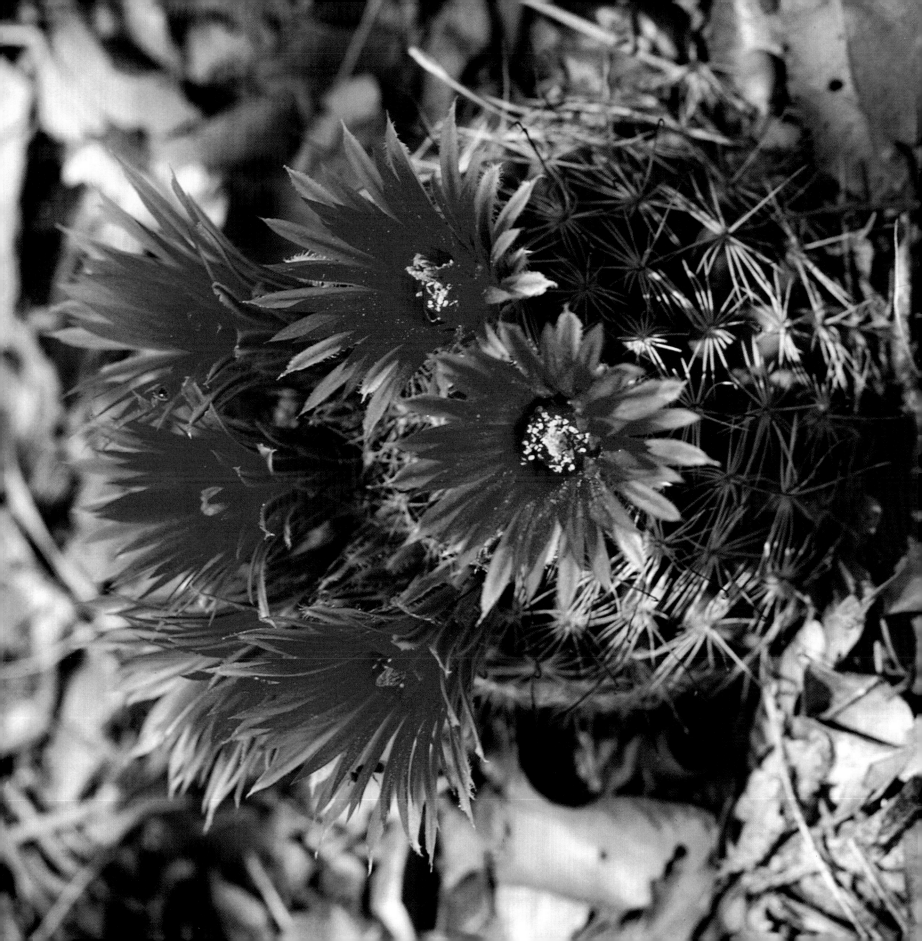

ONCE A WILDFLOWER HAS ESTABLISHED ITSELF, HAVING conquered the particular environmental constraints placed on it by its habitat, it still faces tough challenges before its ultimate goal, the production of viable seed, is achieved. A wildflower's leaves, stems, and roots, so vital in the manufacture, transport, and storage of energy, are choice food offerings for a host of voracious organisms. Although many mammals eat the foliage and seeds of wildflowers and other plants, the greatest threat comes from the thousands of insect species that devour the tissues of living plants. To survive the gauntlet of hungry mouths, many wildflowers, including the bull thistle (*Cirsium vulgare*), have developed formidable lines of defense against their would-be consumers.

One strategy that humans frequently find painfully obvious is of a physical or mechanical nature. The spines and tough hairs of brambles (*Rubus allegheniensis*), stinging nettles (*Urtica dioica*), and teasel (*Dipsacus sylvestris*) discourage the efforts of herbivores. While the armament of these plants is designed to deter deer and other large animals, some wildflowers employ deterrents of a less imposing size. The strongly "pubescent" or fuzzy stems and leaves of mullein (*Verbascum thapsus*), comfrey (*Symphytum officinale*), and showy lady's-slipper (*Cypripedium reginae*) are designed principally to thwart the feeding efforts of mites and tiny insects. Composed of glandular hairs, or needlelike hooks and spikes known as trichomes, these structures physically obstruct the passage of small organisms and cause digestive problems for larger animals. The glandular hairs can also secrete a sticky substance that entraps small invertebrate intruders.

In addition to protecting themselves through mechanical means, wildflowers produce a variety of compounds, such as cellulose, hemicellulose, lignin, and silica, to lower their digestibility. These compounds are used as structural components in cell walls and are difficult, in some cases impossible, for herbivores to digest. Condensed tannin, for example, is downright nasty, as it interferes in the digestive process by blocking the action of digestive enzymes. Consequently, an animal that feeds heavily on plants containing these components will soon become undernourished.

Chemical warfare—so feared in a human conflict—is the most commonplace and effective of all the defenses employed by wildflowers. Wildflower toxins are frequently quite selective, with some toxins affecting mammals or birds and others deterring only insects. The variety of chemicals employed for defense is astounding, and their effects upon the animals that consume them are as varied. Some of the major toxin groups are cyanogenic glycosides, alkaloids, terpenoids (including saponins and cardiac glycosides), and sesquiterpene lactones. By disrupting metabolic activities within the organisms, these toxins affect many important life processes, including cellular activity, food digestion, development, and reproduction.

The incredible array of poisons—tens of thousands of different plant toxins are known presently; many more await discovery—includes some used by humans for "pleasurable" purposes. Caffeine, nicotine, and cocaine are all derived from plant-produced toxins. Many toxins found in plants are used successfully in the treatment of human diseases, such as L-DOPA for Parkinson's disease.

44

STAYING ALIVE

Wherever they grow, wildflowers face an army of hungry consumers. These include groundhogs, Marmota monax *(below left), and snowshoe hares,* Lepus americanus *(below right), as well as larger grazers. The forbidding spines of bull thistle,* Cirsium vulgare *(bottom left), thwart the browsing efforts of virtually all herbivores. One need only look to cattle fields (bottom right) to see just how effective these mechanical defenses really are.*

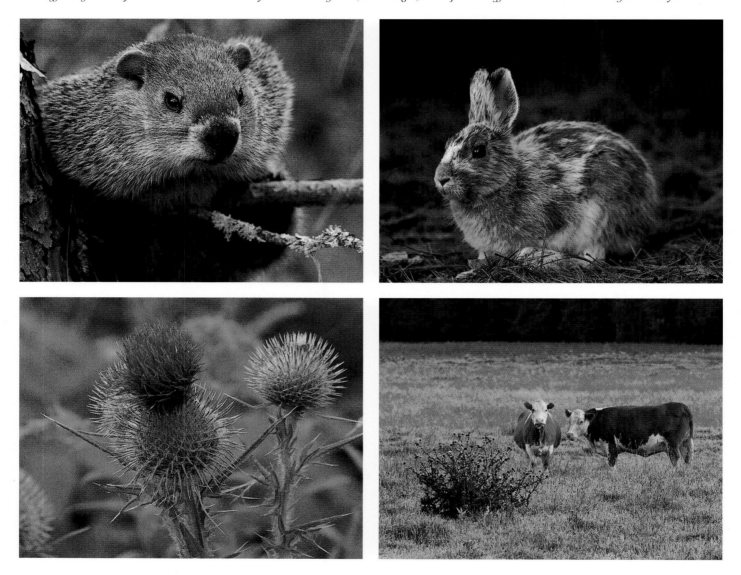

BEAUTY AND THE BEASTS

By far the greatest threat to wildflowers comes from insects, which may be
specialized to feed on virtually any part of the plant. This purple vetch,
Vicia cracca, *is being devoured by a blister beetle,* Epicauta fabricii *(opposite).*
Spittlebugs, family Cercopidae, steal the flower's sap (below).

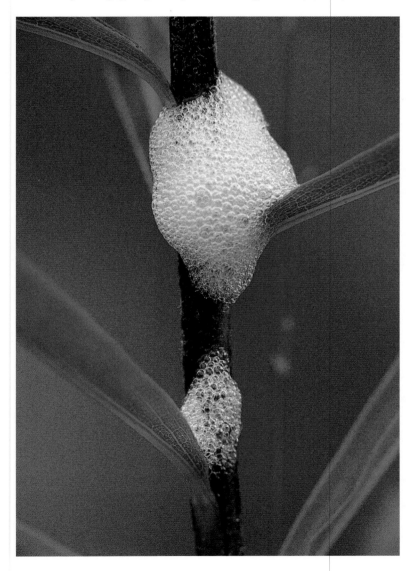

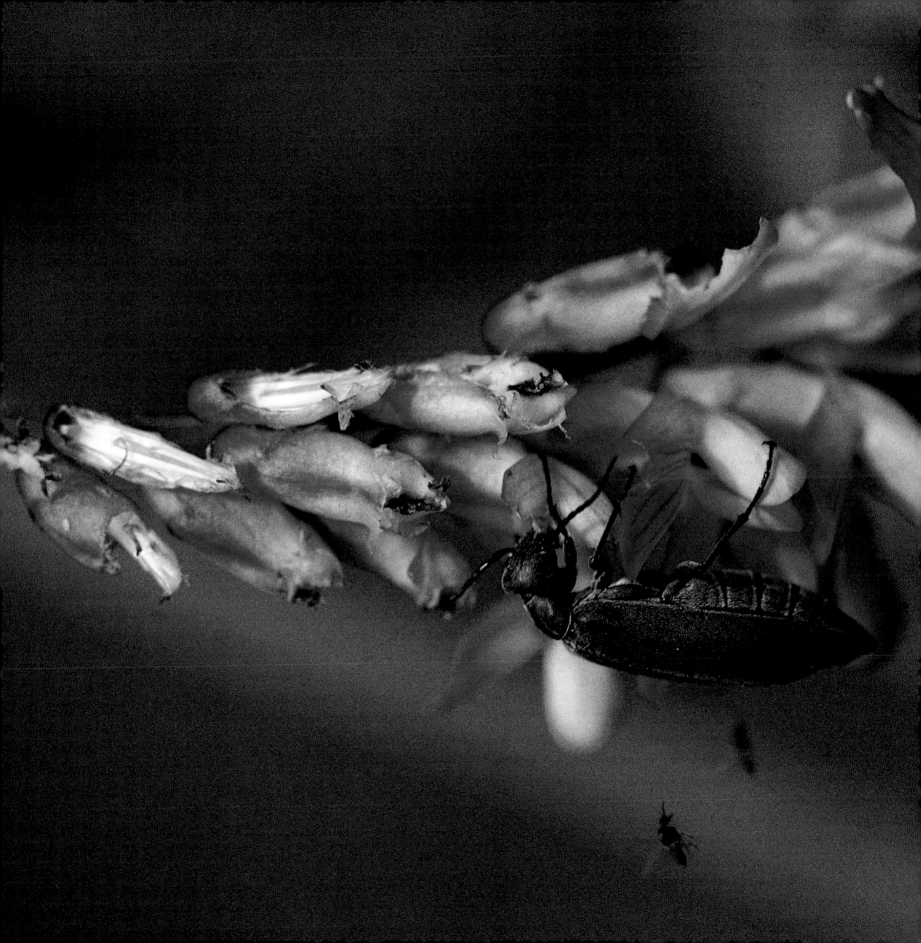

Still other components are potentially fatal. Only a few wildflowers have been analyzed for their chemical toxins, so there is a genuine risk in using wild plants for food or for treating minor ailments. Edible-plant books, for example, recommend the use of comfrey (*Symphytum officinale*) leaves in salads or in tea, yet these books neglect to inform potential users that the wildflower's leaves contain pyrrolizidine alkaloids, which can cause liver damage with repeated use.

In addition to toxins, wildflowers also produce hormones, which can be identical to or mimic animal hormones. Frequently, these plant hormones seriously affect the lives of those that try to consume them. Some plant-produced hormones interfere with mammalian reproduction, for example, and the effects can be as drastic as abortion and infertility. Sheep that graze upon subterranean clover (*Trifolium subterraneum*) often fail to produce lambs. This "clover disease" is caused by the plant-produced isoflavone, which acts like the mammalian hormone estrone. The same chemical also curtails egg-laying in quails. Other chemicals cause insects to remain as larvae and never reach sexual maturity, or to die during a period of growth. Thus, the chemical defenses of certain wildflowers may exert a form of population control on their predators.

While some of this arsenal of chemicals is used primarily for metabolic processes in the plant—with the defensive action an added feature—other chemicals produced by the plant have one simple task: to repel attackers. These secondary compounds or metabolites can be present in fixed levels at all times or are produced in larger quantities when the plant is being attacked. Secondary compounds are sometimes found in all parts of the plant, but are often stored in particularly vulnerable sites, such as buds, new leaves, unripe fruits, or floral parts.

Despite their huge assortment of chemical defenses, wildflowers are never completely invincible. Some animals are able to neutralize certain plant poisons and use the plants as food. Poison hemlock (*Conium maculatum*) and other members of the parsley family (Umbelliferae), for example, produce chemical repellants known as linear furano coumarins. These chemicals react with ultraviolet light and bind to the DNA of the insect consumer. However, the caterpillar of the black swallowtail butterfly (*Papilio polyxenes*) has a very efficient detoxification system and is able to eat the leaves with complete immunity.

A few not only eat the toxins without ill effect but also incorporate them into their bodies, exploiting them for their own defense. The common groundsel (*Senecio vulgaris*) is

Hairs such as those found on the leaves and stems of blackberries, Rubus allegheniensis, *frustrate and hinder the feeding efforts of smaller herbivores (top left). Some leaves are covered in a dense forest of hairs, a line of defense that impedes the physical movement of potential attackers. The extremely fuzzy leaf of a mullein,* Verbascum thapsus, *is shown here (top right). Skunk-cabbage,* Symplocarpus foetidus, *produces leaves that contain calcium oxalate crystals (bottom left). When eaten, these crystals create a burning sensation, thereby rendering the leaves unpalatable. The survival of its leaves is critical to the plant's ability to manufacture and store food, and ultimately reach the seed-producing stage. Many wildflowers, including Canada goldenrod,* Solidago canadensis, *harbor chemicals that are distasteful or even poisonous to insects and small mammals (bottom right).*

powerfully protected by pyrrolizidine alkaloids in its leaves. These compounds are so potent that many cases of cattle poisoning have been attributed to them. Despite this potency, the cinnabar moth (*Tyria jacobaeae*) and the great tiger moth (*Arctia caja*) feed upon the wildflowers with impunity. They also incorporate the chemicals into all of their life stages, even their eggs. Both the caterpillar and moth stages of the two species advertise their protection with bright warning coloration. Another classic case involves the monarch butterfly (*Danaus plexippus*) and milkweeds (*Asclepias*). Some milkweeds contain cardiac glycosides, bitter-tasting toxins. Monarch caterpillars safely consume the leaves of milkweeds, store the toxic compounds in their bodies, and hence become poisonous themselves. When they transform into adult butterflies, the toxins are also passed on. Monarch butterflies and their caterpillars advertise their unappetizing features with vividly colored patterns. Any bird or other predator foolish enough to sample one of these insects quickly learns to avoid them in any future encounter.

Wildflowers frequently announce their unpalatability by emitting pungent odors, producing unpleasant flavors, or appearing in distinct colors. Mustards (family Cruciferae) contain oils that are toxic to most insects, and they advertise

Whenever you see a plant in seed displaying perfect (uneaten) leaves, odds are that unpleasant chemicals are present. The leaves of Indian hemp, Apocynum sibiricum, *contain latex (left), which offers a number of disagreeable compounds to potential consumers. Unpleasant chemicals are also found in common milkweed,* Asclepias syriacus *(right).*

this feature by releasing a pungent, acrid odor.

The fruit of most flowers is designed to be consumed only by animals that disperse the seeds without damaging them. Consequently, berries or other fruit are frequently boldly colored, for two reasons: the color warns non-dispersing consumers that the fruit is to be avoided; and the color alerts the appropriate animals that the fruit is now ready for consumption, and the seeds for dispersal. The bright purple-black berries found on deadly nightshade (*Atropa belladonna*), for example, are poisonous to mammals; yet, birds, which disperse the seeds, eagerly and safely eat the berries. The distinctive smells, flavors,

and appearances of specific wildflowers help to warn insects and other predators to avoid them in future foraging efforts.

The defensive arsenal of wildflowers is indeed diverse. As animals continue to develop neutralizing mechanisms to counter the plants' defenses, plants will evolve new weaponry to fend off their attackers. This great ecological game of chess will continue to be played out as long as plants and animals inhabit this world. And although it is likely that wildflowers will remain one move ahead of their predators, like a game between two evenly matched grandmasters, this contest will never produce a clear winner.

 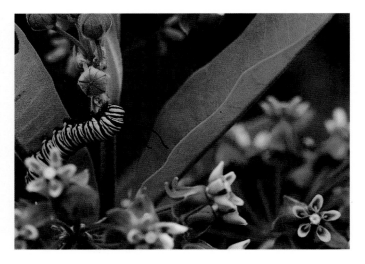

The cardiac glycosides contained in the milkweed's sap (left) discourage many animals from eating the leaves and other parts of the plant. Not all animals are thwarted by a wildflower's chemical defenses. The monarch butterfly, Danaus plexippus, *caterpillar, for example, not only safely consumes the milkweed tissues but also incorporates the poison into its body (right). In doing so, the caterpillar (and the butterfly into which it evolves) reaps protection from the specialized diet.*

CHAPTER FOUR

BASIC INSTINCTS

As it buzzes around the flaming pink fireweed, the bee accidentally brushes against the flower's sticky stigma. A few grains of pollen that had already been stuck to its hairy side are pulled free and, as the bee flies off in search of other feeding sites, remain cemented to this new resting place. Eventually, stimulated by a sugar-rich secretion on the stigma's surface, the bottom of one of the pollen grains begins to swell. Extending from this swelling, a tube penetrates the stigma and gradually advances down the style. As the tube elongates, three nuclei—two sperm in hot pursuit of the tube nucleus—migrate down its length. Finally, the tube reaches its target and pushes into the ovule. One sperm, guided by a chemical trail, encounters an egg and fuses with it; the other consolidates with an endosperm cell. The result of this double fertilization event: a new living embryo and its food supply. Back on top of the stigma, the lifeless pollen grain lies uselessly, its sole biological purpose achieved.

Most wildflowers have adopted safeguards against self-pollination, including self-sterility and separation of the sexual parts. Many, such as bladder campion, Silene vulgaris, *have pistils that mature later than stamens.*

Several wildflowers have two kinds of flowers. The showy blooms of fringed polygala, Polygala paucifolia, *are pollinated by insects (opposite). In addition, tiny, inconspicuous blooms (above left), which never open, are self-pollinating, and thus produce seeds even when the cross-pollinating blooms do not. Self-pollination may be an important strategy for wildflowers such as dandelion,* Taraxacum officinale, *which rapidly colonize relatively new and short-lived habitats (above right).*

THE GUIDING PATH

Like a beacon on a fog-enshrouded shoreline, the bright bloom conspicuously stands out against the dull vegetation. It soon catches the eye of a passing hover fly, which immediately stops in mid-flight, as if it had flown into some invisible barrier. The fly abruptly pivots, then darts towards the distant flower. As it nears, it homes in on a contrasting bull's-eye in the center of the blossom. Living up to its name, the fly hovers inches away. Its antennae quickly locate enticing fragrances, confirmation that sweet offerings await. Landing gear extended, it drops onto the base of a petal, and sensors in its feet soon detect the presence of sugar-rich nectar. The fly quickly extends its proboscis and drinks in the sweet rewards of its search. One after another, the nectar-rich receptacles are paid a visit. But as the fly moves around each bloom, it is unaware that sticky pollen adheres to its body. Unknowingly, the hover fly has become a pawn critical to the flower's overall reproductive scheme.

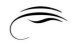

Marsh St. John's-wort, Triadenum virginicum, *displays striking nectar guides, marks that lead insects to the precise location of pollen and nectar rewards and, consequently, a flower's sexual parts.*

CONSPICUOUS BLOOMS, DISCRETE PATTERNS OF COLOR AND smell, and edible rewards are all tools used by wildflowers to ensure that pollination occurs. This process, however, must be achieved as quickly as possible, for the longer it takes, the greater the risk of damage to the bloom by predators or adverse weather. Also, the plant faces a genuine drain on its energy reserves if sweet-tasting or scented enticements are employed for long periods of time. For wildflowers, time means energy, and individual plants resort to a variety of methods to first entice and then guide pollinators to the appropriate sites as efficiently as possible.

Only a few minutes of looking at wildflowers are needed to discover the important role insects play in the pollination process. Bumblebees, flies, wasps, beetles, butterflies—all sorts of insects are drawn to and exploited by wildflowers as couriers of pollen. To attract the insects, rewards ranging from pollen to sugar-rich nectar are often offered. The placement of these enticements, however, does not reflect the plant's desire to satisfy its visitors' appetites. Rather, it reveals a hidden agenda awaiting the obliging callers. The bait is generally strategically placed near the sexual organs so that the insect inadvertently delivers and picks up pollen—usually in that order—in its feeding efforts.

To facilitate pollen transfer as effectively as possible, wildflowers advertise their presence and guide the insects in various ways. A bloom's color is an effective long-range attractant, and certain colors do appeal more strongly to specific insect groups. Bumblebees, for example, are particularly drawn to blue, violet, and purple flowers; hover flies show a preference for yellows; and honeybees react strongly to ultraviolet.

The colors that we perceive are not the same as those seen by insects. Most insects cannot see red (this explains why red wildflowers are so rare and are usually pollinated by hummingbirds, not insects), but many can detect ultraviolet (which humans cannot). Green, the dominant background color for most wildflowers, probably looks dull gray to an insect. One can easily surmise that against such a neutral background, colored blooms stand out even more strongly. Although we will probably never know exactly how insects perceive floral colors, researchers have tried to interpret the visual world of the insect. Flowers that appear yellow to us, for example, are believed to appear "insect-red" or "bee-red" to insects. To human eyes, a mixture of primary colors produces different hues. The same principle applies to insect vision: a mixture of

Many wildflowers attract insect pollinators with such edible rewards as nectar and pollen. Spotted ladybird beetles, Coleomegilla fuscilabris, *the predators of aphids, devour both these offerings in Virginian spring-beauties,* Claytonia virginica *(top left). Bumblebees, subfamily Apinae, pollinate a great variety of wildflowers, particularly blue or purple species, as in this purple vetch,* Vicia cracca *(top right). Because honeybees,* Apis mellifera, *store vast quantities of pollen and nectar, they visit considerable numbers of flowers (bottom left). A pollen-covered solitary bee, family Andrenidae, works a brown-eyed susan,* Rudbeckia hirta *(bottom right).*

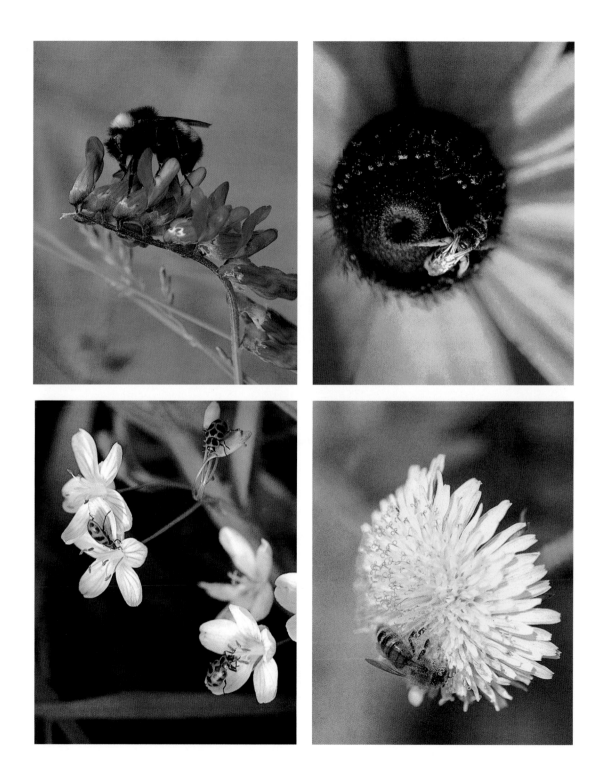

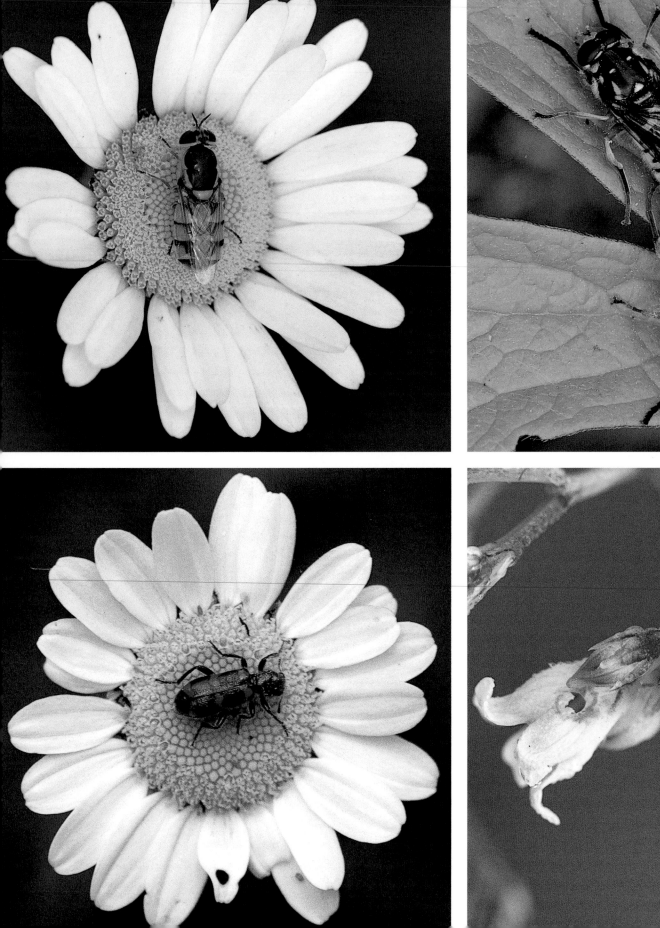
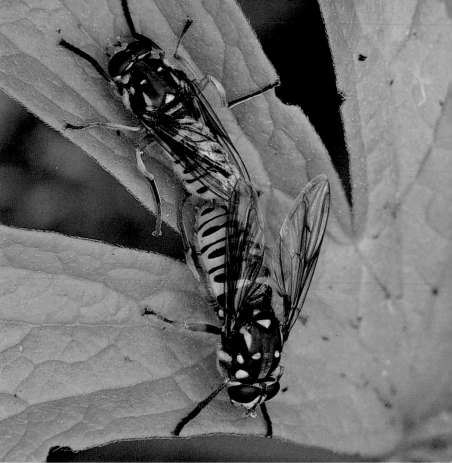

yellow and ultraviolet light produces what is called "bee-purple" or "insect-purple." The illustration at the start of this chapter portrays a patch of brown-eyed susans (*Rudbeckia hirta*) as the hover fly (shown in our color vision) might view them. So when an insect is attracted to a wildflower, it too sees a colorful bloom, but undoubtedly in a much different fashion.

While a bloom's dominant color is important in attracting insects, equally significant is the amazing variety of patterns—spots, stripes, rings, and blotches—found on wildflowers. These may not serve as long-range attractants, but they are critical for guiding insects to the precise location of pollen and nectar rewards and, consequently, a flower's sexual parts. These nectar guides usually appear as contrasting colors that, not coincidentally, are best perceived by the specific insects that pollinate the flowers.

Many nectar guides are quite obvious, yet some patterns are invisible to the human eye. Ultraviolet markings, which are actually more prevalent than the patterns visible to us, are caused by parts of the flower absorbing and reflecting ultraviolet light differentially. Because reflected ultraviolet light mixes with other reflected light to produce distinct colors, areas that absorb ultraviolet more strongly would appear a different color to an insect. To our eyes, brown-eyed susan appears to have completely yellow rays. To an insect, however, the rays appear bicolored because of ultraviolet absorption at their bases. The overall color (yellow to our eyes but "insect-purple" to the pollinators), which is a long-range attractant, is due to carotenoid pigments scattered through the rays. These pigments also reflect ultraviolet light. However, the inner part of the rays also contains flavonols, which strongly absorb ultraviolet light, and appears as "insect-red" to the pollinators. These create a close-range nectar guide to which the insects gravitate.

Odors are also important in short-range guidance. While many scents are pleasant to our noses and attract nectar-eating insects such as bees, others are foul, primarily because they mimic the repugnant odors of carrion or excrement in order to attract certain flies or beetles. Because odors are designed to entice specific pollinators, they tend to be released only when those insects are active. Many wildflowers release odors during the heat of the day, but some wildflowers, including evening-primrose (*Oenothera biennis*), only release their pleasant scents at dusk, when moths and other nocturnal pollinators begin to fly.

Hover flies, here Temnostoma alternans, *are also known as flower flies, because they frequent flowers for pollen and nectar (top left). For defensive purposes, many are marked like bees or wasps. Blow flies, here* Phaenicia sericata, *visit a variety of flowers, including some that smell like carrion or dung. This species is seen resting on a sweet-smelling bloom of spreading dogbane,* Apocynum androsaemifolium *(top right). Note the hole chewed in the bloom by a nectar thief. Soldier flies, here* Odontomyia cincta, *also visit flowers for pollen and nectar (bottom left). Although beetles are not, in terms of pollination, as important a group as bees or flies, some families, such as checkered beetles, family Cleridae, have members that feed on pollen (bottom right).*

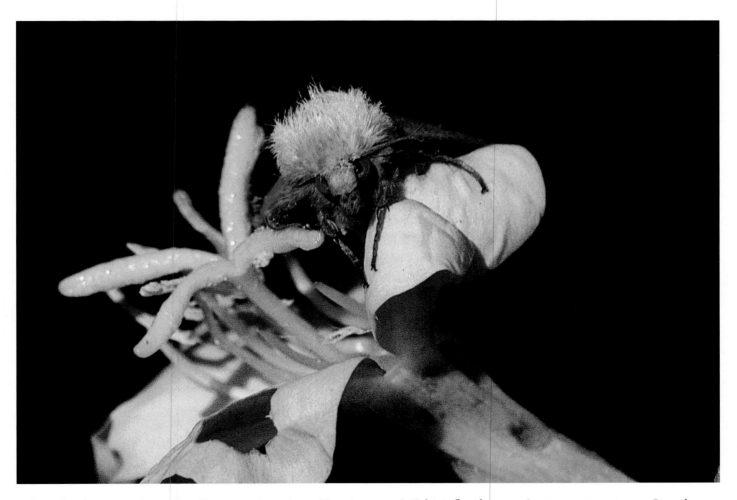

Even after the sun goes down, the pollination cycle continues. The primrose moth, Schinia florida, *not only visits evening-primrose,* Oenothera biennis, *for nectar, but also, as a caterpillar, eats the plant (above). Flower beetles, here* Trichiotinus, *eat pollen and transport it with their body hairs (opposite top). Soldier beetles, family Cantharidae, are commonly found on flowers. In the fall, goldenrods,* Solidago, *may be alive with these insects, here* Chauliognathus pennsylvanicus *(opposite bottom).*

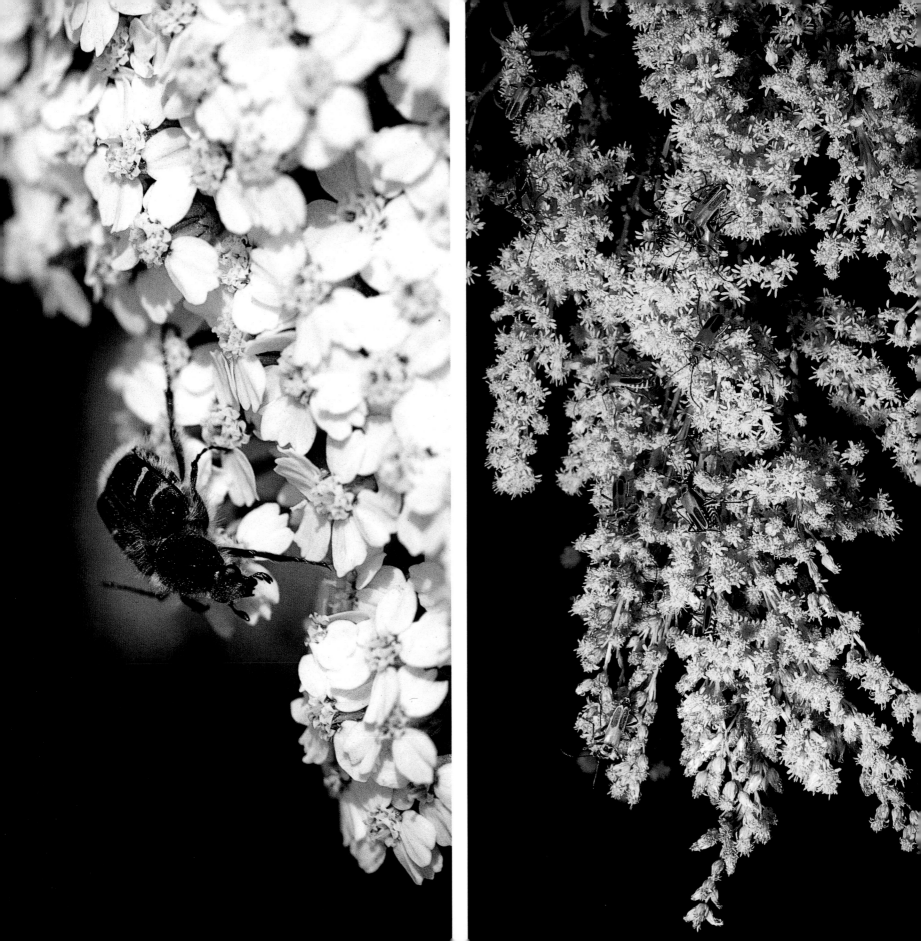

Nectar is the most common edible attractant offered to insects. For some of the flower visitors—butterflies, for example—it may be the only form of nourishment that they obtain in their adult life. Most nectars consist mainly of sugar solutions containing glucose, fructose, and sucrose. The combinations of these sugars differ greatly between wildflowers, and the sugar concentration may also vary within an individual flower at different times of the day (due to evaporation, which causes a greater concentration of sugar).

The amount and type of sugar present determine the type of insect that feeds at the flower. Glucose and fructose nectars tend to be more popular with short-tongued bees and bee flies (family Bombyliidae); sucrose-dominated nectars attract long-tongued bees, butterflies, and moths. And nectars that are rich in amino acids occur in flowers visited by carrion and dung flies (families Calliphoridae and Scathophagidae).

The nectar is held in special sites called nectaries. The location of these sites varies widely and allows access to only those insects with the appropriate mouthparts. The nectaries may be held in open cups, which are easily accessed by a variety of short-tongued insects, including beetles and bees; others are found in remote spurs and thus are only available to insects bearing long proboscises, such as butterflies and moths. The nectaries may also appear in grooves at the petal bases, in special "nectar leaves" (modified petals) including spurs, or at the base of the bloom. In addition to the location, structure, and content of the nectaries, the amount and type of pollen produced also facilitate visitation by specific insects.

Certain groups of insects or other animals are often ranked according to their perceived importance as pollinators. This can be rather misleading, however. For example, because bees visit more types of wildflowers than most other insects, they are deemed to be important pollinators. Yet, for a wildflower that is only pollinated by hummingbirds, these insects are completely insignificant. Importance is really quite relative.

In terms of varieties of flowers visited, without question the most important group of pollinators is honeybees and bumblebees (family Apidae). They are attracted to wildflowers for both pollen and nectar. Honeybees (*Apis mellifera*) visit phenomenal numbers of flowers in their foraging efforts. To produce one kilogram of honey, it is estimated bees have to visit at least twenty million flowers! This is because they store large amounts of food for the winter (they survive as a colony year-round, unlike bumblebees, which die in the autumn). Since bees have relatively short mouthparts, the flowers they visit tend either to produce great quantities of pollen or to hold nectar in relatively accessible nectaries, such as in short spurs.

Although flies are considered to have less importance as pollinators, some types of these insects are commonly found at wildflowers. Hover flies (family Syrphidae), in particular, regularly visit flowers for both their nectar and pollen. Many of these harmless flies bear the same color patterns as bees and wasps, a guise that helps them avoid being eaten by other animals. Because hover flies and bee flies often have longer mouthparts than bees, they are able to draw nectar from flowers with

deeper nectaries. While these two families are the major groups of pollinating flies, a variety of representatives from other families also visits flowers and takes part in the pollination process.

Certain groups of beetles, particularly the longhorn beetles (family Cerambycidae), soldier beetles (family Cantharidae), and checkered beetles (family Cleridae), contain pollinating members. These beetles have biting or chewing mouthparts, used for either feeding on pollen or lapping up exposed nectar. In their feeding efforts, pollen is transferred usually rather inefficiently from flower to flower.

Perhaps surprisingly, butterflies and moths rank last in their overall importance as pollinators. Their long proboscis-

es are ideal for extracting nectar from long, narrow spurs, the same structures that frequently thwart the feeding efforts of other types of insects.

Both in terms of complexity and individual ingenuity, the world of wildflower pollination is remarkable, and one can easily understand the captivation it held for the great naturalists, including Charles Darwin. While much of the underlying mechanisms have been uncovered, many discoveries still await the naturalists of today. Yet, as we are unable to see wildflowers through the eyes of insects and other pollinators, we may never be capable of fully deciphering all of the intricate relationships that remain hidden to our blunted senses.

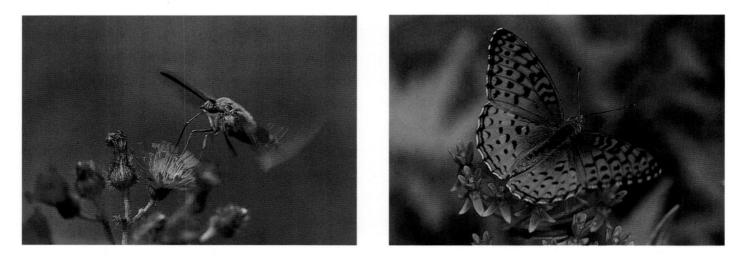

Not all moths visit wildflowers at night. The hummingbird clearwing, Hemaris thysbe, *visits orange hawkweed,* Hieracium aurantiacum, *and other wildflowers during the day (above left). Some wildflowers, such as butterfly-weed,* Asclepias tuberosa, *are pollinated by the aphrodite fritillary,* Speyeria aphrodite, *and other butterflies (above right). Overall, however, butterflies and moths are less important pollinators than are other insect groups.*

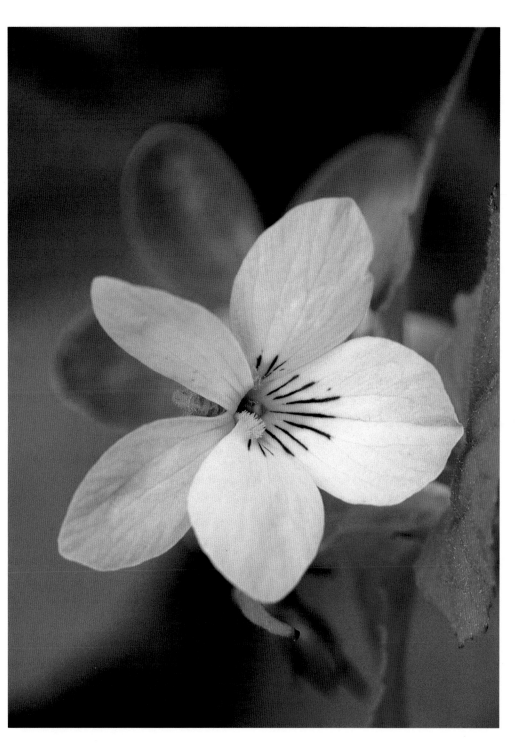

In Canada violet, Viola canadensis, nectar guides are in the form of inward-directed lines (above). Also note the yellow guide patches at the petal bases. Once an insect approaches a flower, specific color patterns guide it to the reward location near the flower's sexual organs. As in hedge bindweed, Convolvulus arvensis (opposite), these nectar guides may appear as contrasting petal patterns.

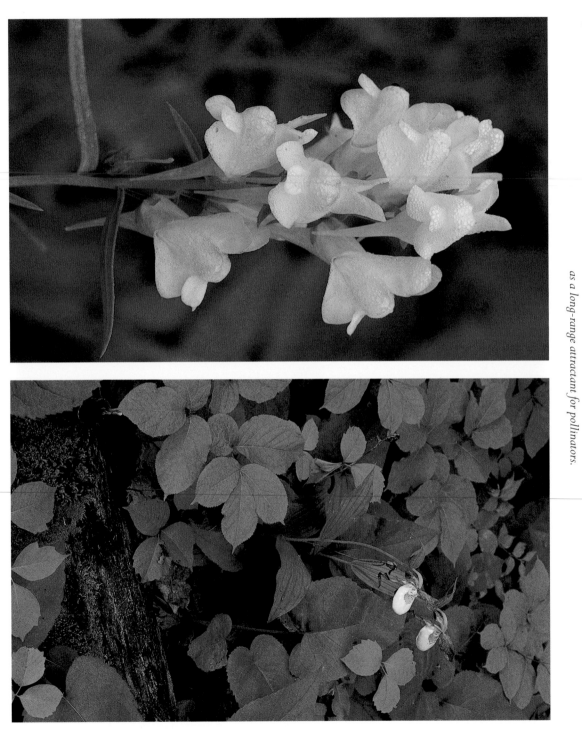

In butter-and-eggs, Linaria vulgaris, nectar guides appear as as discrete petal colors (below left). The bright color of both wood lily, Lilium philadelphicum (opposite), and yellow lady's-slipper, Cypripedium calceolus (below right), contrasts with the surrounding vegetation and serves as a long-range attractant for pollinators.

BEAUTY AND THE BEASTS

76

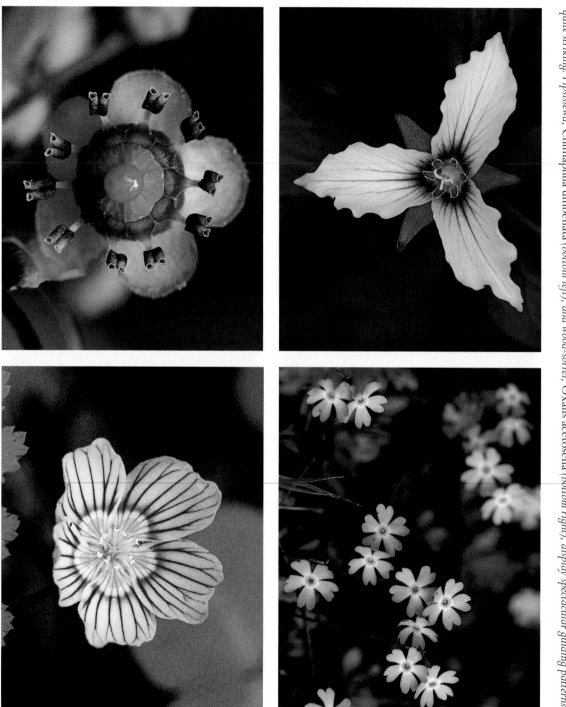

Nectar guides appear in many forms. They may be contrasting petal bases, as in the painted trillium, Trillium undulatum (below left), blotches, as in dragon's-mouth, Arethusa bulbosa (opposite), or rings, as in bird's-eye primrose, Primula mistassinica (below right). The nectar guides are frequently quite striking. Chimaphila umbellata (bottom left), and wood-sorrel, Oxalis acetosella (bottom right), display spectacular guiding patterns.

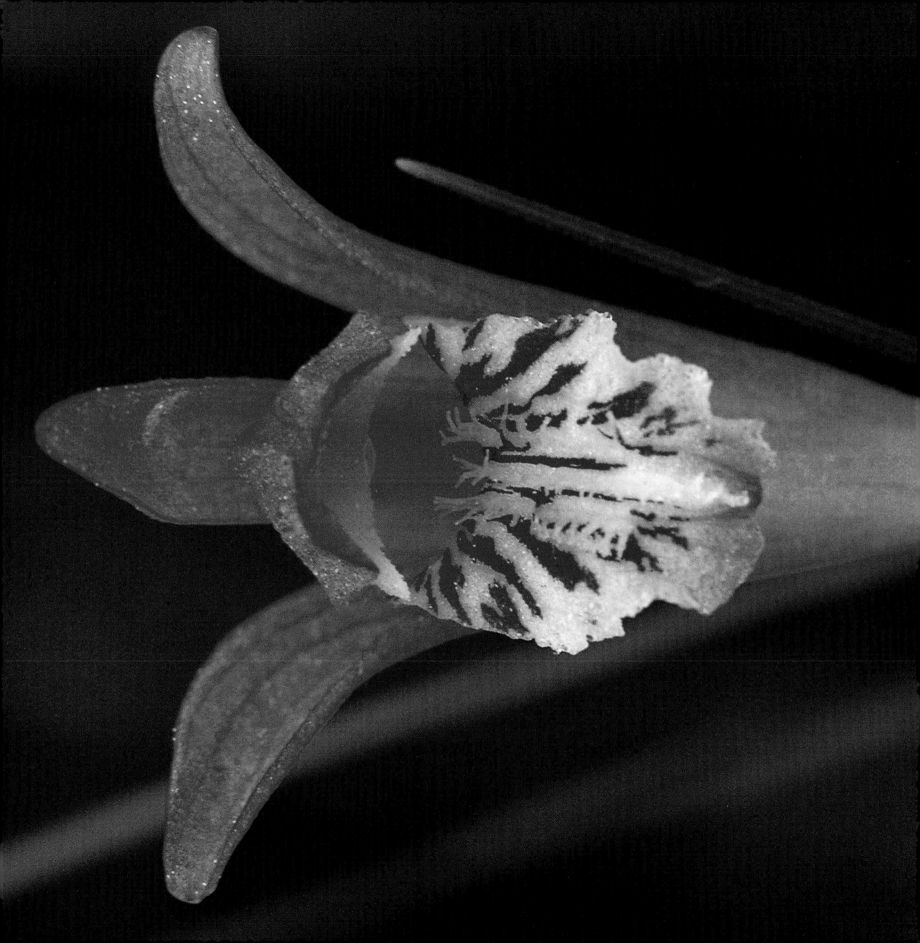

While we are able to perceive some of the nectar guides, others are visible only to insects. The following is a selection of flowers that have ultraviolet nectar guides. The color image we see is coupled with a black-and-white image that shows the regions where ultraviolet light is absorbed (appearing black in this version).

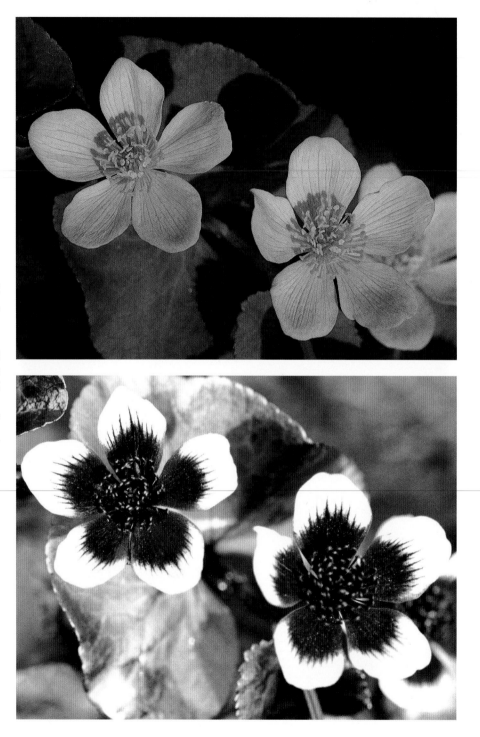

Marsh-marigold, Caltha palustris.

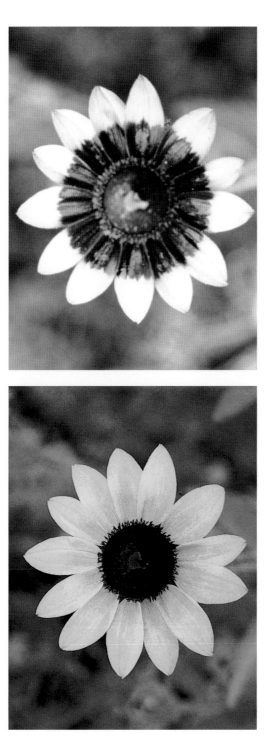

Brown-eyed susan, Rudbeckia hirta.

Woodland sunflower, Helianthus divaricatus.

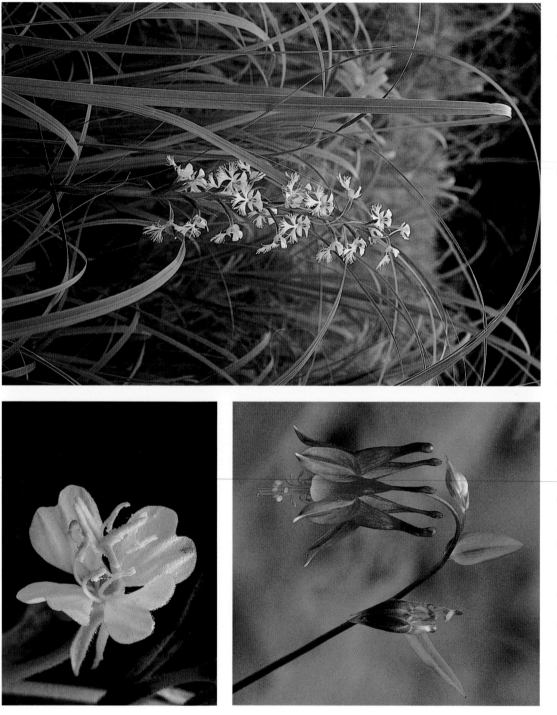

Wildflowers also use scents as close-range attractants. While many species release their odors during the day, prairie white-fringed orchid, Platanthera leucophaea, releases its sweet fragrance at dusk, when its moth pollinators begin to fly (below left). Evening-primrose, Oenothera biennis, not only releases its scent at dusk but also stays closed until this time of day (bottom right). Nectar rewards are housed in the remote spurs of columbine, Aquilegia canadensis (below right), and are accessible primarily by long-tongued pollinators capable of hovering (hummingbirds, for example).

THE GUIDING PATH

Remote nectaries and red coloration are indicators that cardinal-flower, Lobelia cardinalis, is pollinated by hummingbirds (below left). Albino wildflowers, such as this ram's-head lady's-slipper, Cypripedium arietinum, lack the proper visual attractants and guiding systems, and thus are disadvantaged in terms of successful pollination (below right). Although butterflies have long proboscises, they do not hover and must sit on the blooms in order to feed. A coral hairstreak, Satyrium titus, contentedly sips nectar on a butterfly-weed, Asclepias tuberosa, blossom (bottom right).

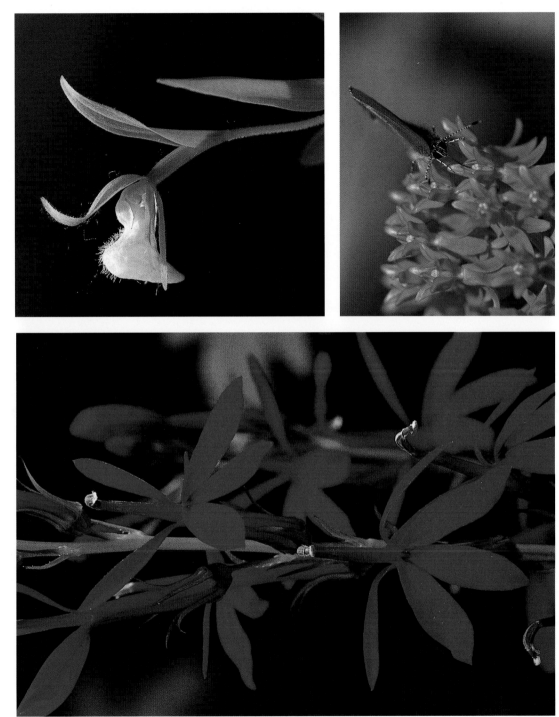

CHAPTER SIX

WORLD OF DECEPTION

The vegetation below becomes a dull blur as the bee speeds towards its distant target. When the radiant blossom it seeks looms closer, a swollen mass of pollenlike objects on the top petal becomes the sole focus of its attention. The bee's tiny feet finally contact floral parts, and a frenzied search begins for the sweet reward that is eagerly anticipated. But just as its sensors begin to relay the message that something is wrong—that no pollen can be found—a bizarre chain of events is set in motion. The petal suddenly lurches forward, carrying its hapless visitor in a downward course. As quickly as it began, the journey ends, a winged, curved trough having rudely interrupted the petal's fall. Pinned upside down by the weight of the petal to which it still clings, the bee struggles to escape from this floral coffin. The prisoner's back rubs against the sticky stigma, and any pollen the bee might be bearing is removed while a generous dose of glue is smeared on. In its crawl to freedom, the frantic bee brushes against the pollen sacs, which adhere to its now sticky back. Free at last, the bee rushes off, an unwillingly carrier of the cargo that will be removed upon the bee's next encounter with the same flower species.

While many wildflowers exude sweet odors, those of red trillium, Trillium erectum, *are most unpleasant. The odor and color are designed to attract flies seeking rotting flesh.*

84

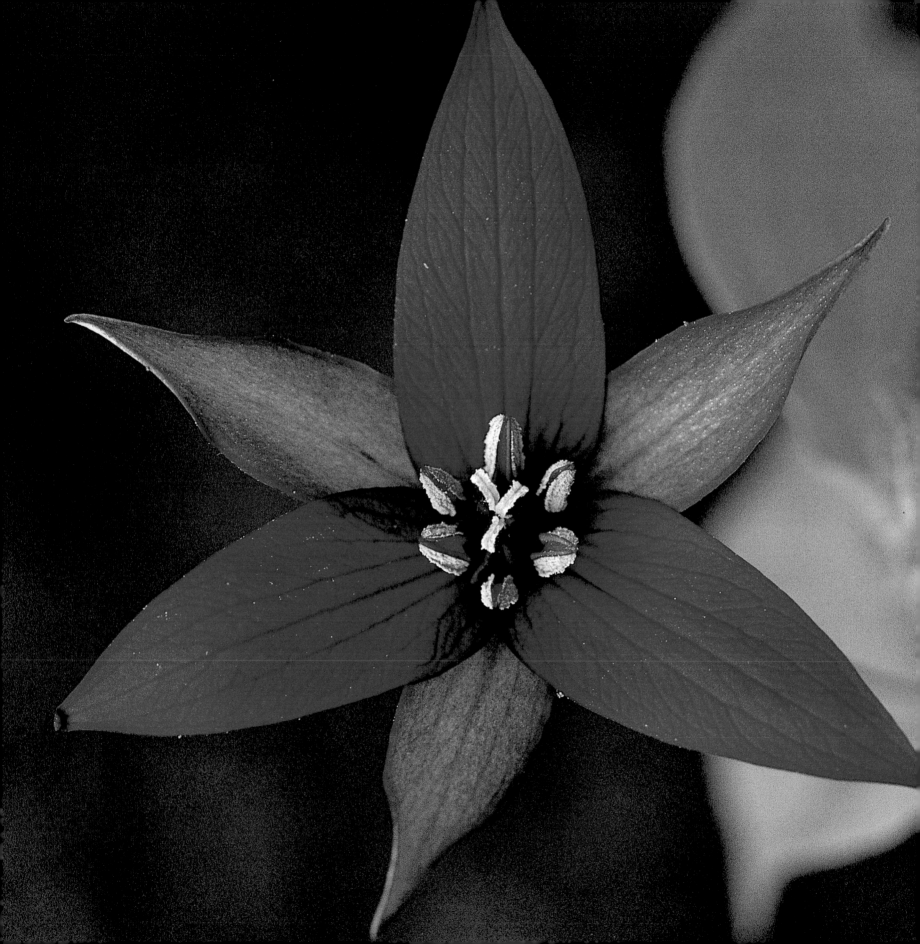

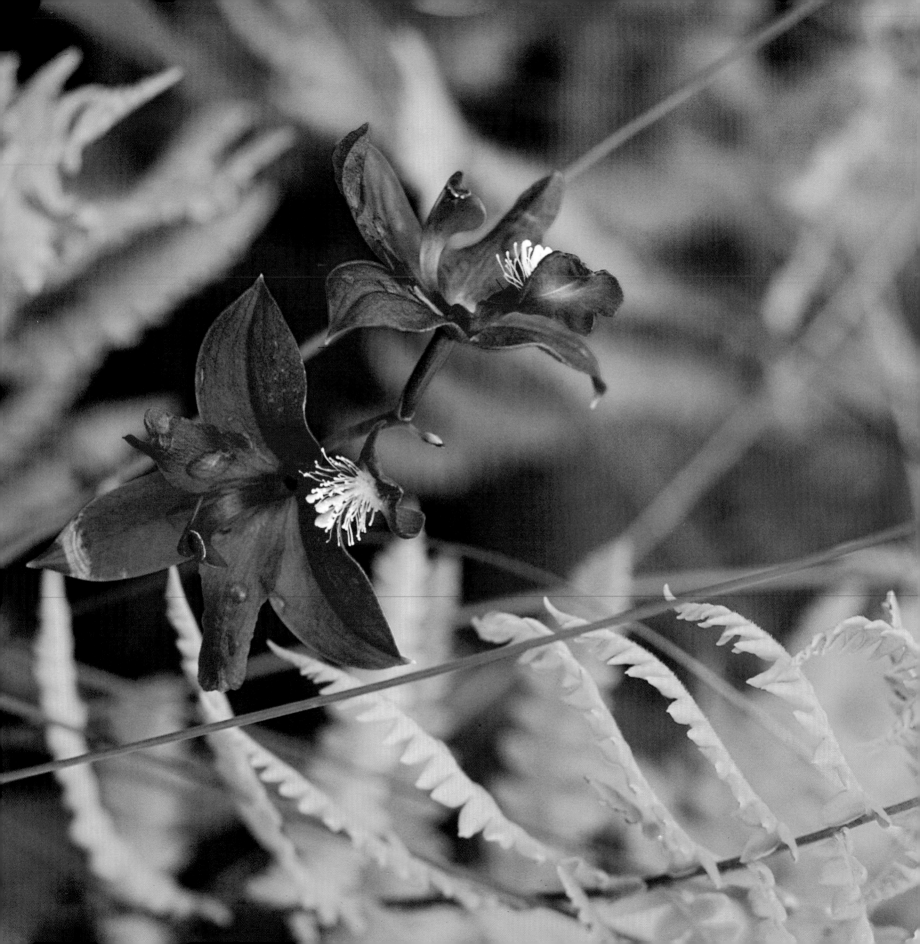

BY USING LURES OF IRRESISTIBLE SCENTS, COLORS, AND FORMS, and by offering edible rewards of nectar and pollen, wildflowers exploit one basic need of insects—the need to eat. In the process of acquiring nutrition, these biological couriers unwittingly deliver pollen to and from the flowers. Most of the time insects are rewarded for their efforts, but there are also times when they are exploited by wildflowers. The amazing pollination trap of the beautiful grass-pink (*Calopogon tuberosus*) described in the chapter's opening is one of many elaborate and intricate deceptions that wildflowers have evolved to exploit their insect callers.

For any deception to work, the flower must model at least part of itself after another flower (or some other desirable object) that does offer genuine rewards. Otherwise, insects would soon learn that their efforts in visiting a deceptive flower are a waste of time and energy, and the attractiveness of that bloom would quickly fade. While we often think of animals when we discuss the world of mimicry, wildflowers also provide us with many fascinating examples. For mimicry to be successful, the floral coloration should match that of reward-offering wildflowers found in the same habitat and that bloom at the same time of year. In the case of the grass-pink, the pseudo-stamens closely resemble genuine pollen-bearing structures found in other wildflowers. The floral color is also similar to such nectar producers as sheep laurel (*Kalmia angustifolia*), which blooms at the same time and in the same bogs.

Deceptive pollination devices are perhaps best manifested in the orchid family (Orchidaceae), to which the grass-pink belongs. Intrigued by orchid pollination, Charles Darwin wrote in *The various contrivances by which orchids are fertilised by insects* that "the contrivances…are as varied and almost as perfect as any of the adaptations in the animal kingdom."

One of the most striking of all orchids is the calypso or fairy slipper (*Calypso bulbosa*). Pollination studies of this spectacular wildflower have uncovered that bumblebees are its primary pollinator. However, this flower produces no nectar reward, instead relying on its color resemblance to nectar-producing flowers that bloom in the same region. The fact that bees are intelligent insects and learn quickly that no reward means a waste of effort is probably the reason for only a small percentage of each calypso population achieving pollination each year.

Although orchids do demonstrate incredible pollination "contrivances," other wildflowers also portray equally dynamic and devious mechanisms to ensure that pollination occurs. Many flowers attract insects through deceit, mimicking the sweet smells or enticing appearances offered by other plants. Not all insects, however, dine on sweet-smelling foods. Some groups seek out somewhat less appealing (at least by human standards) items. (One need only examine roadside animal fatalities to discover that a variety of insects either eats or lays their eggs on the decomposing flesh.)

As red trilliums (*Trillium erectum*) are pollinated by flies that lay their eggs on dead animals, one might predict that they should

Grass-pink, Calopogon tuberosus, *displays false stamens to entice bees to visit its bloom (opposite).*

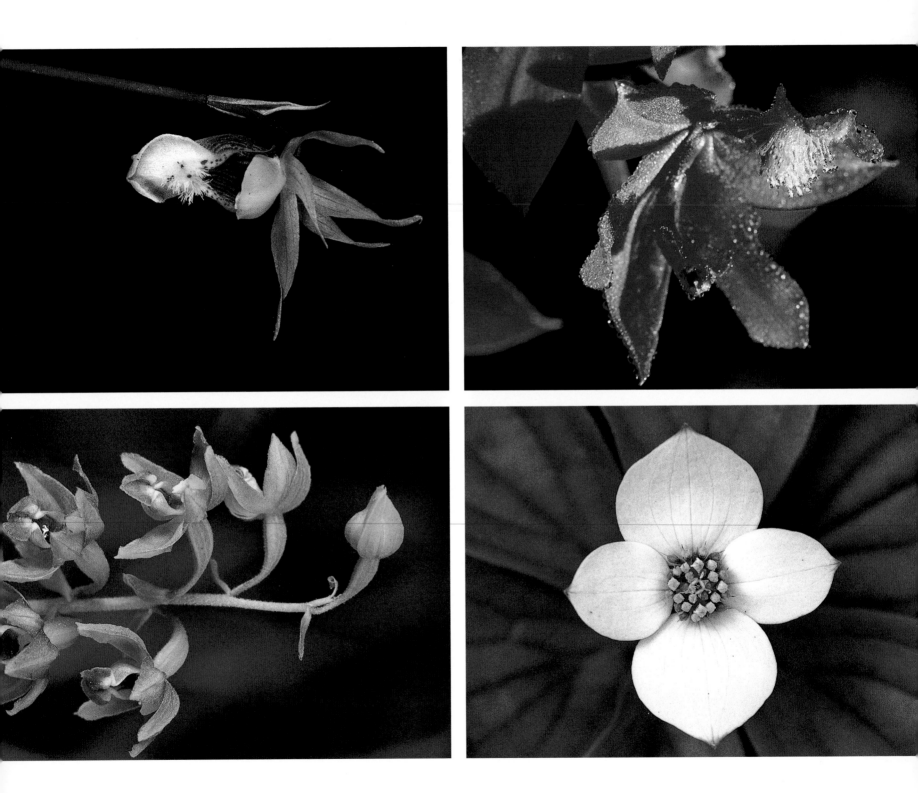

smell rather unpleasant. This is indeed the case, and the foul odor produced has given rise to the unusual nickname "stinking Benjamin." In addition to the olfactory enticement, the illusion of a rotting corpse is no doubt furthered by the trillium's wine-colored petals, which possibly create a visual attraction by mimicking the appearance of exposed flesh. When the flies are lured in by the color and scent, their fruitless wanderings over the floral parts ensure pollen transfer.

Not all of the deception that awaits insect foragers is of such a passive nature. Many wildflowers, including the grass-pink, also employ much more animated mechanisms to ensure that pollination proceeds. So formidable are some of these instruments of sex that it would appear they could be used as weapons of war.

The bunchberry (*Cornus canadensis*), a common flower of coniferous or mixed woods, for example, has been called the "pop flower" because of its explosive pollination mechanism. The pale yellow-green bunchberry flowers are clustered at the confluence of white bracts, which are really specialized leaves, not petals (as they are so often thought to be). They first arise as closed, ball-like structures. The hairlike appendage or "antenna" acts as a hair trigger. When an insect trips this mechanism, the flower violently explodes, showering the undoubtedly surprised visitor with a dose of sticky pollen. Fully open in a

split second, the flower soon displays its female parts, which will accept pollen from the next insect courier.

Although much less dramatic in design than the explosive device of bunchberry, trip devices are also employed by the exquisite pink sheep laurel (*Kalmia angustifolia*). In fact, the other species of laurel all exhibit similar design. The twelve pollen-bearing stamens are pinned back, under pressure, in receptacles in the petals. The weight of a visiting insect causes the stamen arms, or filaments, to spring free and catapult upwards, greeting the visitor with a sticky dose of pollen. These catapults can be easily set off with a pin, a matchstick, or a fine twig.

Many wildflowers employ devious means of ensuring that insect visitors leave with pollen. However, common milkweed (*Asclepias syriaca*) also sends insects away with special containers holding the pollen. Each milkweed flower contains a number of nectar cups. When insects arrive to drink the sweet offering, their feet slip into slits on the side of the flowers. When they pull their feet out, the tiny claws catch on threadlike structures bearing bags of pollen at each end. These clamp onto the insect's legs and resemble miniature saddlebags dangling from its feet. While the insect is in flight, the bags twist around and close together. There they remain until the insect visits another milkweed flower, where the saddlebags are deposited inside the floral slits.

As considerable strength is needed to pull the saddlebags

The modified hair lures of grass-pink, Calopogon tuberosus, *are held on a collapsing petal, which traps the insect visitor in a winged trough below (top left). Bunchberry,* Cornus canadensis, *has also been called the "pop flower" for its explosive pollination mechanism (top right). Calypso or fairy-slipper,* Calypso bulbosa, *offers false promises to its insect visitors, for it holds no nectar (bottom left). Of all our wildflowers, orchids, here helleborine,* Epipactis helleborine, *display the greatest variety of novel pollination strategies or contrivances (bottom right).*

free from the flower, larger insects such as the monarch butterfly (*Danaus plexippus*) are the principal pollinators. Although smaller insects may have the pollen bags clamp onto their feet, because they lack the strength to pull free, they may be imprisoned by the flower and end up fatally trapped.

In the case of the milkweed, insects are only trapped by accident. In other instances, however, insects are intentionally confined as part of the pollination mechanism. The elegant lady's-slipper orchids (*Cypripedium*), generally pollinated by bees, all have a modified petal that forms a pouch or "slipper." The pink lady's-slipper (*Cypripedium acaule*) has a slit in the front of its pouch. Drawn to this flower by its pink color and sweet odor, a bumblebee lands on the pouch and muscles its way through the inward-leading slit. When it enters the pouch, the slit closes, trapping the bee inside the roomy chamber. Lining the upper part of the pouch are sticky, light-colored hairs with nectar drops. These hairs, along with light emitted through translucent areas in the petal, entice the bee to the upper part of the pouch. Here, the pouch constricts below two small exits to the outside. To escape, the bee must crawl under a large, flattened structure—the staminode—which forces the bee's back to rub against the female sexual parts. Any pollen the bee might be carrying is scraped off, and pollination proceeds. Finally, as the bee escapes through one of the strategically placed exit holes, it rubs against sticky packages of pollen, which adhere to its back.

This marvelous piece of design is not always appreciated by potential pollinators. In many species of lady's-slippers, holes are visible indicators of where bees ate their way through the pouch, having ignored the carefully laid-out escape route.

Other species of *Cypripedium* lack the slit entrance in the pouch but still entice bees into the top of the pouch and encourage them to leave via the two side openings.

As Charles Darwin observed, orchids display a rich variety of contrivances. A favorite pollination strategy of mine involves the tiny twayblades (*Listera*). These minute wildflowers are generally pollinated by small wasps or flies. Upon landing on the enlarged landing platform—all orchids have one of their three petals enlarged for this purpose—the insect is lured inward by a trail of nectar drops. As it nears the central part of the flower, the insect's back rubs against the column (the structure containing the sexual organs). Even the slightest touch will cause part of this structure to explode and shoot off canons of glue. As the sticky mass descends, it pulls the pollen sacs with it. Upon landing on the hapless insect's back, the glue dries in less than two seconds, cementing the load of pollen there. Once the glue and pollinia are gone from the column, the female parts mature and may even drop closer to the landing platform. When an insect returns with a load of pollen (probably from another flower), the sac ruptures against the stigma, and the pollination cycle is complete.

The stamens of sheep laurel, Kalmia angustifolia, *are pinned back in grooves and are violently released when an insect comes into contact with them.*

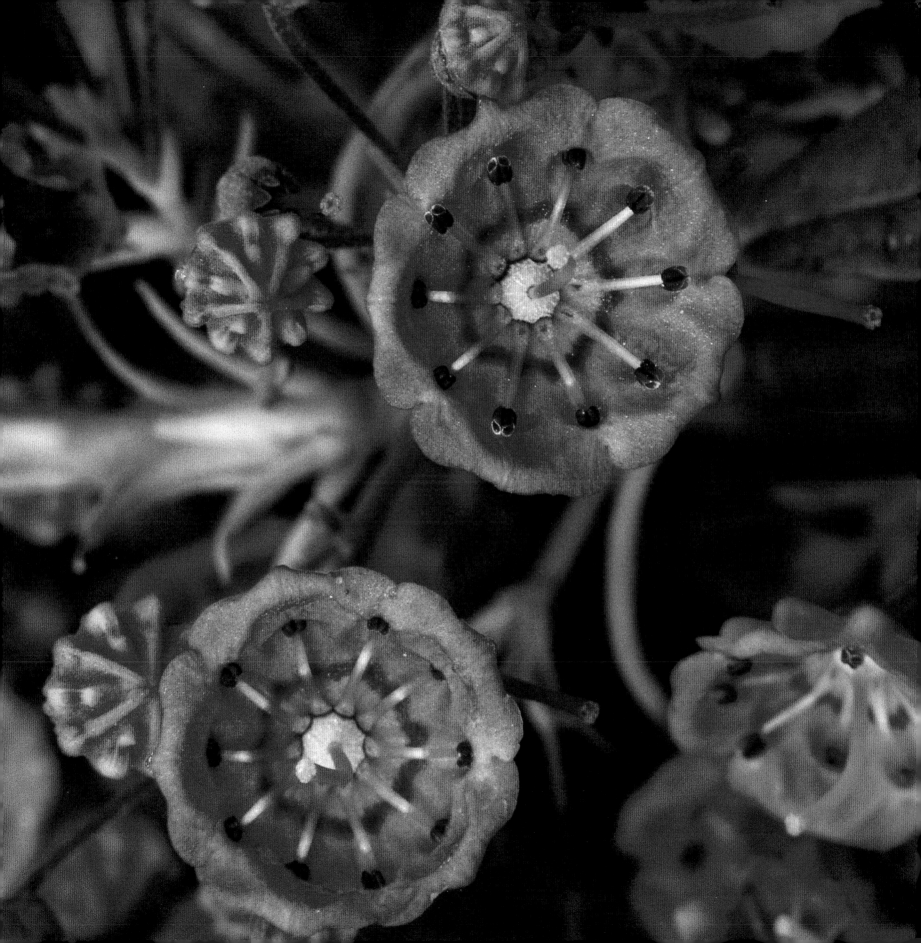

Perhaps the most unusual form of deception employed by a wildflower involves the use of one of the strongest lures possible in the animal kingdom. A group of European orchids and a few other species from more tropical regions have transformed their petals into the appearance of female insects. *Ophrys* orchids, commonly called bee or wasp orchids, look and smell like a desirable female wasp or bee. The flowers also produce scents that resemble the chemical attraction signals (pheromones) emitted by these female insects. When the male insect arrives, his sexual appetite is fueled further by contact with the landing platform, which may have a "furry" feel to it. During the ensuing but fruitless copulation attempts (known as pseudocopulation), pollen transfer is initiated. To ensure that their deceitful lures are irresistible, the orchids bloom at the time the males emerge, which usually precedes the appearance of the females by a week or more.

Wildflowers certainly hold plenty of surprises for their insect visitors. Although the majority of these floral encounters allow the animals to escape unharmed and complete their assigned tasks, more lethal adventures lie in wait as well. A great number of predatory animals also capitalizes on the drawing powers of flowers, and life-and-death scenarios are continuously played out in virtually every patch of wildflowers.

Sitting motionless, their crablike front legs held out with deadly patience, crab spiders (families Thomisidae and Philodromidae) await insect visitors. Unlike many other types of spiders, crab spiders do not build webs and depend upon ambush to capture prey. Their colors usually blend well with the blooms on which they rest, and one common species, the goldenrod crab spider (*Misumena vatia*), is actually able to transform its color to match the flower.

Other predatory insects—some with intriguing names such as assassin bugs (family Reduviidae), ambush bugs (family Phymatidae), praying mantids (family Mantidae), and robber flies (family Asilidae)—also exploit the powerful attraction that wildflowers hold for insects. These deadly creatures can usually be found lurking either on or very close to the blooms. In many cases, the irresistible lure of a wildflower turns out to be a fatal attraction for an unsuspecting insect visitor.

Exploring a patch of wildflowers on a sunny summer afternoon is always a fascinating experience, for a wealth of captivating dramas is sure to unfold. Before your eyes a bunchberry flower explodes when a solitary bee trips the hair trigger. Or perhaps with lightning speed a hover fly is snared from the air by a praying mantid. The actions of pollination mechanisms and the life-and-death struggles of predator and prey on wildflower blossoms render our human-produced suspense and science fiction adventures relatively tame by comparison!

The beauty of pink lady's-slipper, Cypripedium acaule, *catches not only our eye but also the eyes of foraging bees (top left). The bee is guided into a narrow slit that leads into the pouch (top right). Once trapped inside, the bee is led upward by a trail of hairs and a translucent area at the top of the pouch. To escape, the bee must crawl under the depressed staminode (bottom left). The sexual parts are situated on the underside of the staminode (bottom right). First, the bee's back meets scrapers on the stigma. As it finally exits, the insect brushes against the sticky pollen masses, which partially block both exits.*

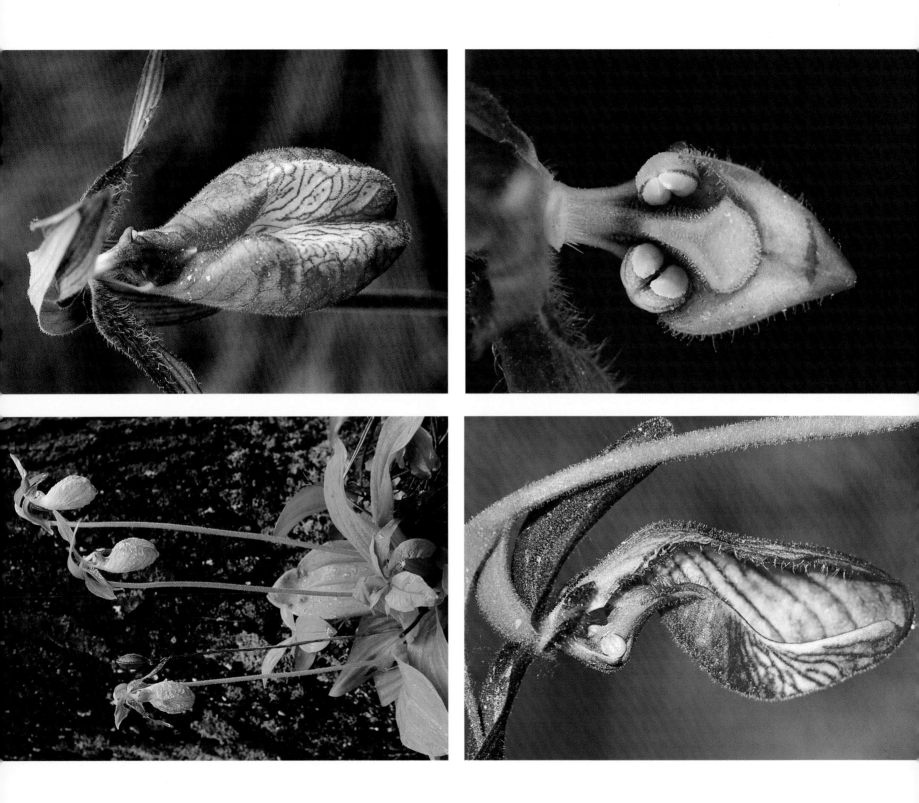

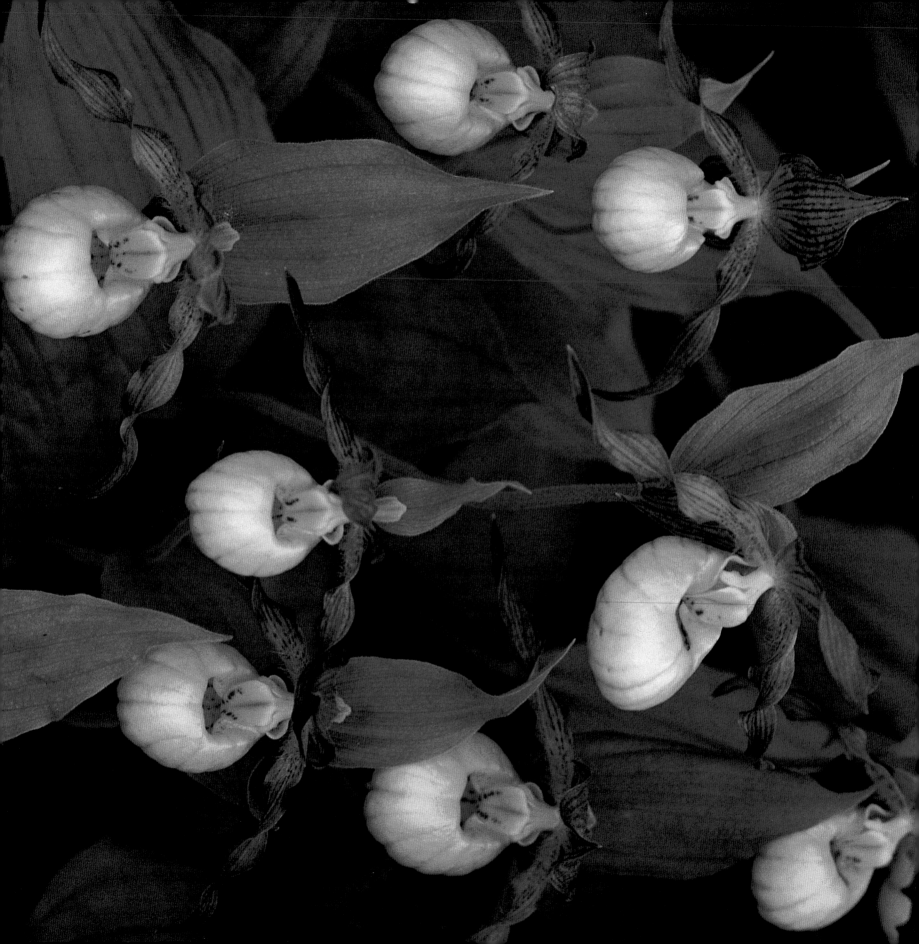

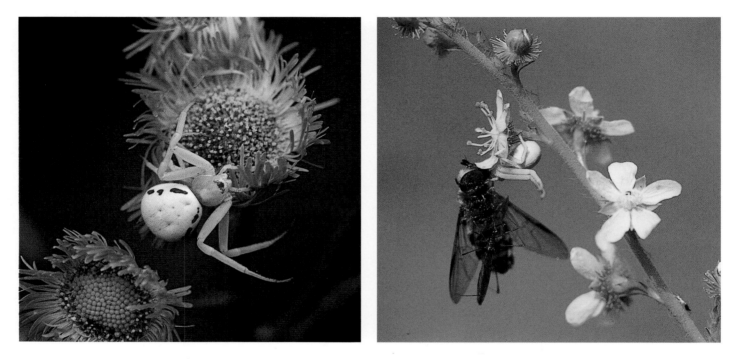

Yellow lady's-slipper, Cypripedium calceolus, *also has one petal enlarged into a pollination trap but, unlike pink lady's-slipper, has the top of its pouch open for insect entry (opposite). The lure of a flower may turn into a fatal attraction, for many predators lie in waiting. Crab spiders, here* Misumena vatia, *frequently lurk on the blooms of philadelphia fleabane,* Erigeron philadelphicus, *and other wildflowers (above left). This hover fly (above right) got more than it bargained for when it visited the hooked agrimony,* Agrimonia gryposepala. *Both a crab spider and an assassin bug have nabbed it. It would have been intriguing to have followed this drama to the end, for one can only speculate as to the effects of the predators' toxins on each other.*

CHAPTER SEVEN

GETTING AROUND

With its antennae combing the ground for anything edible, the ant busily climbs over the maze of sticks and fallen leaves. Nearby, a tiny seed skips unnoticed across the hard, dry leaves on the forest floor. Seconds later, another seed shoots out from a contracting pod overhead. This time the seed lands beside the ant, and its presence is immediately noted. The ant rushes over and, by stroking the object with its antennae, instantly recognizes it as a choice food. With powerful mandibles, it grasps the seed by a mass of white material bulging at one end. It struggles to keep the prize off the ground as it follows a chemical trail back to the colony. There, the seed is delivered underground to a chamber already partially filled with other seeds collected by the ant and its siblings on previous foraging expeditions. Its precious cargo safely delivered, the ant scrambles back to the outside world to seek more of these edible items.

Once a wildflower such as starry false solomon's-seal, Smilacina stellata, *has produced seeds, one challenge remains—dispersing them to an appropriate site.*

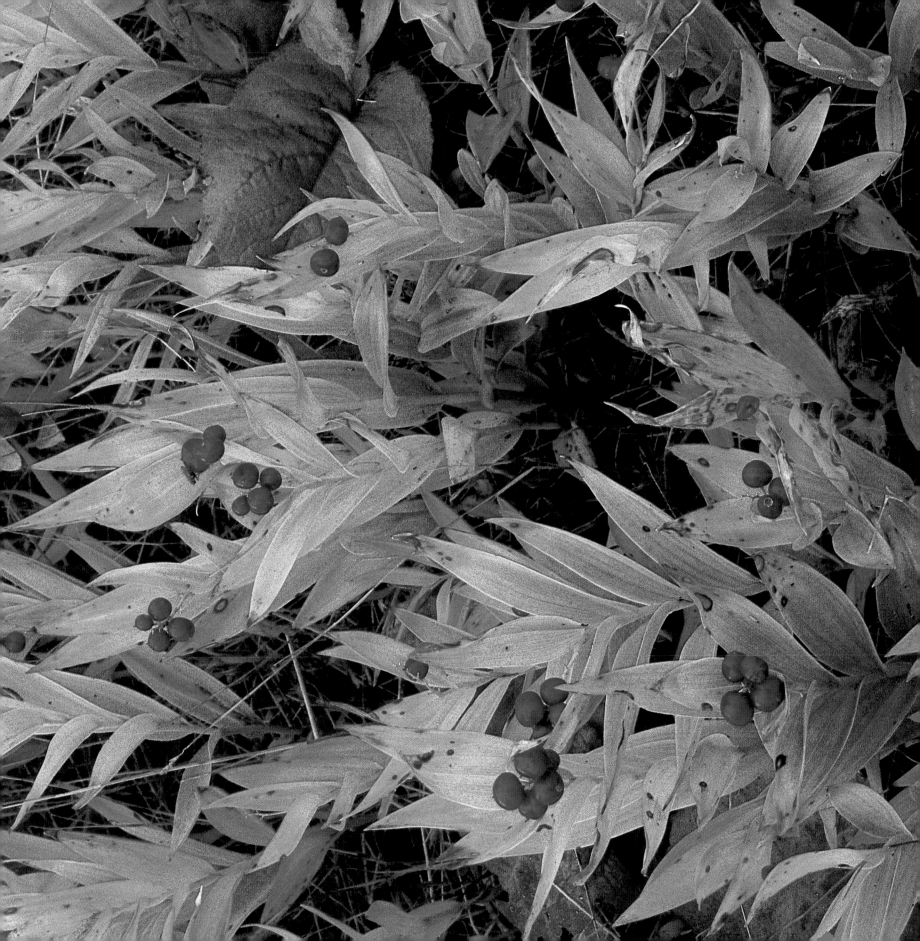

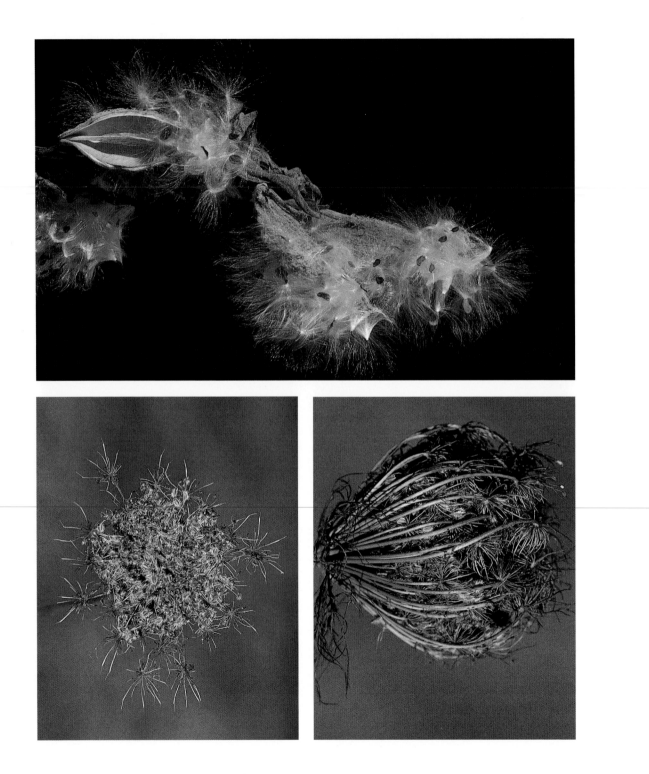

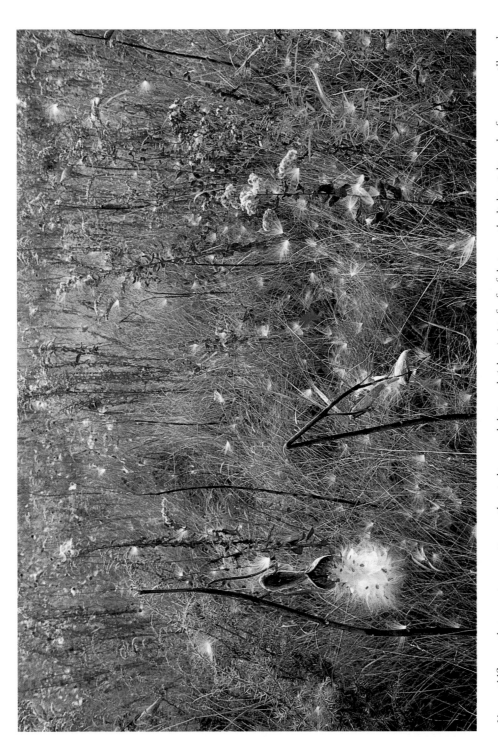

Many wildflowers that grow in open sites use the wind to spread their seeds (above). A tuft of soft hairs on the lightweight seeds of common milkweed, Asclepias syriaca, assists their aerial sojourns (opposite left). During adverse weather when seed dispersal would not be successful, some wildflowers protect their seeds from the elements. The umbel of Queen Anne's lace, Daucus carota, closes up during overcast or moist days (opposite, top right) and opens under the influence of sunshine (opposite, bottom right).

ALTHOUGH IT MIGHT APPEAR THAT THE WILDFLOWER'S TASK IS completed once seeds are produced, this is not the case, for the seeds must reach a favorable environment in order to have a reasonable chance of germinating. It seems logical that wildflowers growing in marginal or poor habitats would profit by having their seeds delivered to new sites with more resources. However, even in hospitable environments, there are benefits in having the seeds dispersed. By having progeny grow at some distance from the parent plant, crowding and competition for nutrients may lessen, parasites or diseases of the parent may be avoided, and the odds improve that at maturity pollen transfer will take place with, in terms of genetic history, an unrelated plant. Thus, wildflowers, regardless of where they may grow, attempt to spread their seeds afar, even (as illustrated in the chapter opening) exploiting animals in their efforts.

How a seed is sent off from the parent plant depends partly on the environment in which the wildflower grows. If a habitat is of a temporary nature, seeds that are able to travel large distances may be advantageous. Areas with tree cover removed by man, insects, wind, landslides, or fire tend to be relatively short-lived habitats. These open sites are colonized by wildflowers and other plants that require unrestricted light. However, larger plants such as trees and shrubs will invade the site through time, creating a shady environment that virtually excludes those initial colonizers. Thus, the first wildflowers

to thrive in these open habitats—fireweed (*Epilobium angustifolium*), hawkweeds (*Hieracium*), common milkweed (*Asclepias syriaca*), goldenrods (*Solidago*), and the ubiquitous dandelion (*Taraxacum officinale*), to name a few—often employ the strategy of producing lightweight seeds, which are easily windblown to new locations. To aid in their aerial dispersal, the seeds are often equipped with a tuft of silky or woolly fibers, scales, or bristles. These may be given a specific name, like the pappus found on the seeds of members of the Compositae family. All of these structures act like sails or parachutes, providing a large surface area for the wind to act on.

Despite the marvelous modifications many of these seeds have undergone, seed dispersal by wind is not foolproof. Because they are at the wind's mercy, the seeds are frequently carried to the wrong habitat, including large bodies of water. The odds are extremely low that an individual seed will land in a favorable site. For this reason, wildflowers that depend on the wind for seed dispersal tend to produce a prolific number of seeds. Some wildflowers—fireweed, for example—may produce as many as fifty thousand seeds per plant. Orchids are particularly prolific seed-producers, with a number of species producing more than a million seeds per plant. Just like playing a lottery game, the more seeds a plant produces, the better the odds of one seed successfully reaching a suitable site.

While wind dispersal is a common strategy for wildflowers

Often the wind-catching aids are elegantly designed. Such are the plumelike bristles that adorn the achenes (seed capsules) of yellow goat's-beard, Tragopogon pratensis *(bottom). Equally elegant are the plumes of virgin's-bower,* Clematis virginiana *(top).*

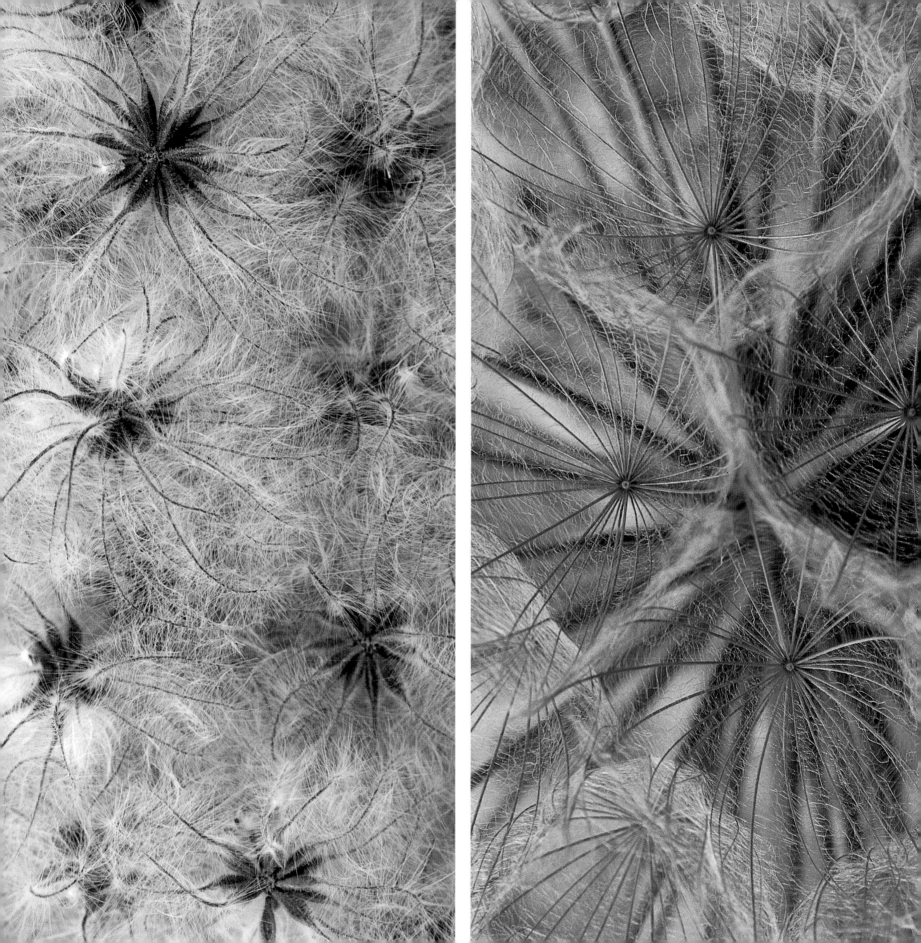

growing in open sites, it is by no means the only one. Common mullein (*Verbascum thapsus*) produces copious amounts of seeds that lack structural adaptations for wind dispersal and are fairly heavy compared to other wildflower seeds in the same habitat. When they disperse, they tend to fall from the flowering stalk and travel only a relatively short distance. This might seem to be a poor strategy, for if the habitat were to change unfavorably, the seeds could not escape. However, the mullein is still successful: rather than flee a changing habitat, its strategy is simply to wait for the habitat to change back to a more tolerable one. The seeds of mullein are capable of lying dormant in the soil for at least a century. Then, if the habitat is again opened by the actions of man, wind, insects, or fire, the mullein seeds are in place and ready to germinate.

Still another strategy employed by plants in open sites is the use of animals as dispersal agents. This can be accomplished in two fashions. Some seeds behave like hitchhikers, traveling on the hairs of mammals or on the feathers of birds. Wildflowers such as burdock (*Arctium*), Queen Anne's lace (*Daucus carota*), and sticktight or beggar-ticks (*Bidens*) are transported by animals. Their seeds are held in fruits, which may be surrounded by hooklike bracts (as in burdock) or have barbs on the fruit itself (as in the achenes of beggar-ticks). These appendages catch easily on the hairs (or in some cases the feathers) of passing animals, allowing the seeds to reach new sites eventually, where they either fall off or are pulled out by the animal. An inspection of your pantlegs after an autumn stroll through an old field will quickly reveal how well this dispersal strategy works.

While some seeds travel on the outside of unsuspecting animals, others travel inside them. A variety of wildflowers produce sweet fruits that many animals find irresistible. Animals ranging from American Robins (*Turdus migratorius*) and Cedar Waxwings (*Bombycilla cedrorum*) to raccoons (*Procyon lotor*) and black bears (*Ursus americanus*) eagerly swallow the fruits and pass the seeds with their droppings. Wildflowers such as blueberries (*Vaccinium*), strawberries (*Fragaria*), and raspberries and blackberries (*Rubus*) produce tasty fruits, which we also relish. However, unlike our wild counterparts, we rarely complete the dispersal cycle in a fashion favorable to seed germination!

The entire seed dispersal process would be an exercise in defeat if the fruit were to be consumed before the seeds matured. To discourage predation, unripe berries and other

While some seeds soar through the air, others travel closer to the ground. Many sun-loving plants exploit hairy animals such as this red fox, Vulpes vulpes, *for their seed dispersal (top left). The wicked-looking barbs of beggar-ticks,* Bidens frondosa, *enable the achenes to stick to virtually any coarse surface—hence, the plant's other common name, sticktight (top right). As far as great burdock,* Arctium lappa, *is concerned, woolly clothing is a fine substitute for the hairy coat of a mammal (bottom left). The flower heads of great burdock (bottom right) are enveloped by strongly hooked bracts. These readily catch onto any hairlike structure.*

fruits usually employ chemical defenses. Before they reach maturity, the fruits are usually bitter in flavor. Only when the seeds are ready for dispersal do the fruits become sweet with sugars. Accompanying the change in edibility is a change in color and smell, strong advertisements to inform foragers that the fruit is now ready to eat.

This method of dispersal requires that an animal eat the flesh of the fruit but not damage the seeds held within. To withstand physical punishment from teeth, beaks, and digestive tracts, as well as the acid bath encountered inside an animal's stomach, the seeds of these fruits have extremely hard coats.

Some animals unintentionally disperse seeds as they store food for winter consumption. Various squirrels, including red squirrels (*Tamiasciurus hudsonicus*) and eastern chipmunks (*Tamias striatus*), frequently stash seeds that are never eaten and eventually germinate.

A variety of animals disperses the seeds of wildflowers. Although many birds and mammals are important to the dispersal process, much smaller organisms also play vital roles. In certain habitats—especially in environments that tend to be relatively persistent, such as mature forests, deserts, and grasslands—violets and other wildflowers exploit ants for their seed dispersal. This technique is also particularly prevalent among the early-flowering plants of the hardwood forest: in a New York beech-maple forest, for example, almost thirty percent of all the understory wildflowers were found to use this type of dispersal.

Ants do not distribute the seeds as an act of goodwill. Rather, their sole interest is in the special edible packages attached to the seeds. Known as elaiosomes, these ant foods appear as visible white swellings, often in the form of girdles, caps, or fingerlike extensions at the ends of the seeds. Foraging ants carry the entire seeds back to the colony, where they feast on the elaiosomes, which usually contain proteins, sugars, lipids, starch, and vitamins. The seed itself is of no use to the ants and so is discarded. In the enriched environment of the ant colony and with reduced competition from other plants, these seeds eventually germinate.

The seeds of violets are ultimately dispersed by ants, but are initially sent away from the parent plant in a forcible fashion. When violet seeds mature, the pod that contains them opens up into three sections. The seeds are held in these three canoe-shaped receptacles, which begin to compress and pinch in along the sides. As the pod squeezes against the seeds, it causes them to shoot out of the pod, landing up to a metre, or three feet, away.

Velvet-leaf blueberry, Vaccinium myrtilloides, *and other wildflowers that depend on animals for their seed dispersal signal the ripeness of their fruit through a color change (top left). Ripe berries are particularly attractive to raccoons,* Procyon lotor *(top right), and black bears,* Ursus americanus *(bottom left). Having successfully survived the trip through a bear's digestive tract, wild raspberry,* Rubus strigosus, *seeds lie in a bed of natural fertilizer (bottom right). The "end result" is that the seeds have been transported to a new and potentially suitable environment for germination.*

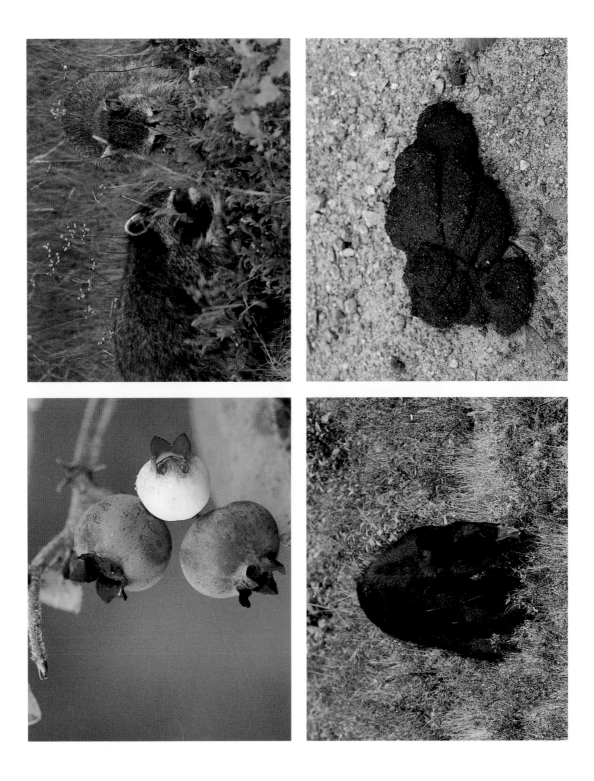

As with many spring ephemerals of the hardwood forest, painted trillium, Trillium undulatum, produces seeds dispersed by ants (above). These are held in the bright seed capsule until they are mature. Even though ants transport the entire seed, they are only interested in eating the fleshy swelling known as an elaiosome (opposite, top left). The seeds of violets, Viola, are also transported by ants (opposite, top right). But by the time they are discovered by these insects, they have already undergone a dramatic journey. When the seeds are mature, their seedpod contracts sideways, forcibly ejecting the seeds. The seeds of touch-me-not, Impatiens capensis, also undergo ballistic ejection. The mature seed capsule (opposite, bottom left) develops considerable tension and, with the slightest physical contact, violently explodes open, scattering the seeds (opposite, bottom right).

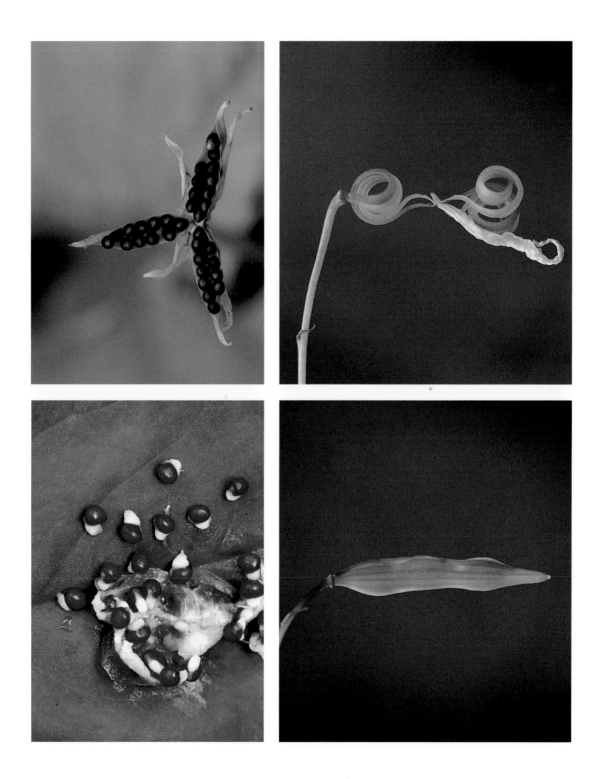

Known as ballistic ejection, physical seed ejection is also performed by orange jewelweed, or spotted touch-me-not (*Impatiens capensis*). Indeed, this wildflower comes by its latter name honestly. Touch-me-not has elongated seed capsules composed of straplike segments. As the seed pods mature and extend, each segment develops a pressure similar to that of a stretched spring. When fully mature, the slightest touch causes the segments to spring free and catapult the seeds up to three metres, or about ten feet, from the plant. Walking through a large patch of touch-me-nots on a dry day in autumn is like walking through a field of grasshoppers. Everywhere, small objects go hurtling by as distinctive snapping sounds fill the air.

While many wildflowers depend on a single type of seed dispersal, others, including violets, may employ more than one method. The common plantain (*Plantago major*) uses two methods to disperse its seeds, but only one strategy is implemented at any given time, as both are dependent upon climatic conditions. On dry days, the tiny seeds are dispersed by the wind; on rainy days, the seeds exude a sticky gelatin that can adhere to the wet hairs of passing animals.

Every habitat, even wetlands, offers unique challenges for its wildflower inhabitants. Wildflowers adapted to life in a water-logged world also demonstrate modifications for seed dispersal in this environment. Many water-loving wildflowers, including blue flag (*Iris versicolor*), produce seeds that have flotation devices. Fragrant water-lily (*Nymphaea odorata*) actually produces a life-raft to transport its seeds to a new location. When its flowers are fertilized, the water-lily stems begin to twist, pulling the now-closed flowers underwater. Here the seeds mature. About a month later, the flower receptacle falls apart, allowing the seed containers known as arils to float to the surface. After several days of floating around, the arils disintegrate, liberating the seeds into the water.

Wildflowers have risen admirably to the challenge of dispersing their seeds to new sites. As demonstrated in every other aspect of their life histories, they show incredible ingenuity in solving this important problem. Wind, water, and animal power have all been harnessed to spread their seeds out into the world around them. Through a variety of elegant adaptations, wildflowers succeed not only in ensuring that their progeny have a reasonable chance of arriving in a site favorable for germination but that, ultimately and most importantly, they continue to carry on their genetic lines for at least one more generation.

Summer is the time for growth and reproduction, and the majority of wildflowers, including Canada goldenrod, Solidago canadensis, *disperse their seeds in late summer or autumn.*

While early-blooming hardwood forest wildflowers often employ ants for dispersal, later flowering plants such as Indian pipe, Monotropa uniflora, use the wind (above). With the leaves off the trees by late autumn, winds blow through this habitat, making this form of dispersal possible. Originally pointing to the ground, the flowers become upright (opposite, left). The tiny seeds develop inside the now-brittle pods. When the seeds are ready to be dispersed, the capsule splits. The seeds slowly filter out of the cracks, like grains of salt sifting out of a shaker (opposite, top right). Many wildflowers in a variety of habitats use the wind to disperse their seeds. The seeds of cardinal-flower, Lobelia cardinalis, are spread along shorelines and other damp habitats through this method (opposite, bottom right).

JUST FOR THE BEAUTY

"A lily of a day,

Is fairer far in May,

Although it fall and die that night;

It was the plant and flower of light.

In small proportions we just beauties see."

Ben Jonson, *"To the Immortal Memory of Sir Lucius Carey and Sir H. Morison"*

Wildflowers live in a world full of challenges. Germination and growth in demanding habitats, survival amongst hordes of hungry predators, exploitation of unknowing pollinators, dispersal of seeds into hospitable environments—all phases of their lives require novel and often inventive adaptations. Every aspect of their biology equally deserves our attention.

But wildflowers are also living masterpieces. Their glorious colors and forms beautify our visual world. Their sweet fragrances perfume the air we breathe. Their silent gracefulness and charm stir our souls. And so we cannot help but marvel at their indisputable magnificence.

The power and splendor of wildflowers is celebrated in this photographic tribute.

Bullhead-lily, Nuphar variegatum.

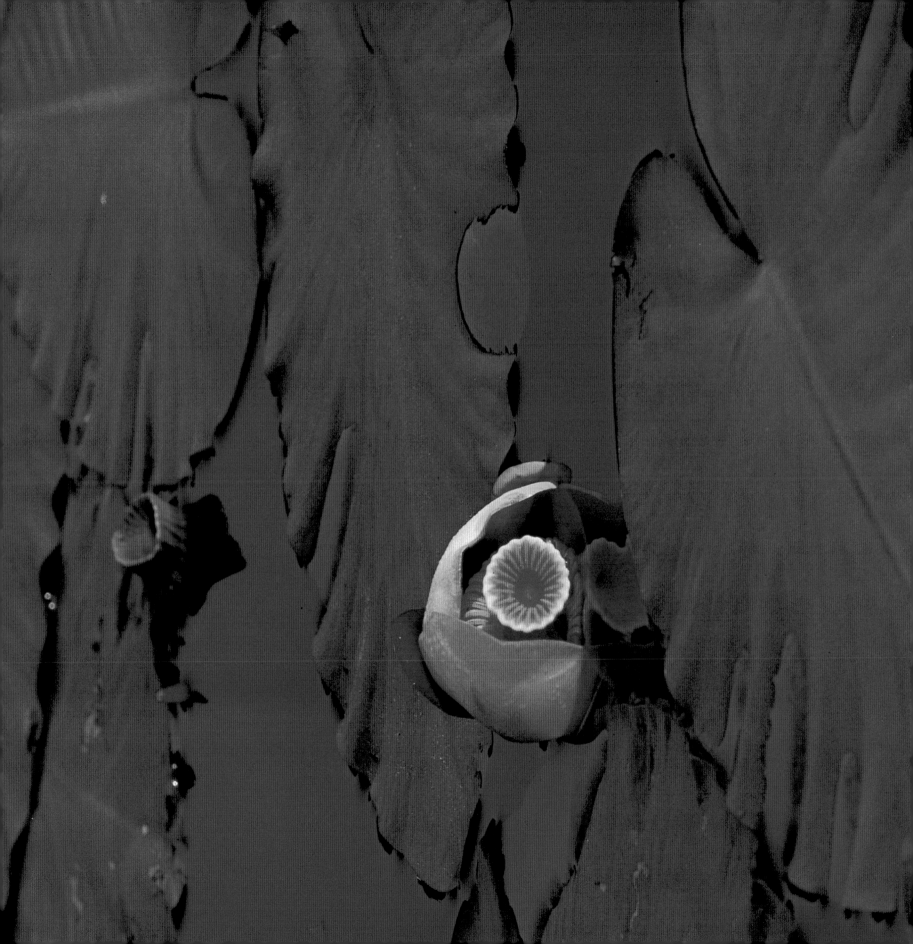

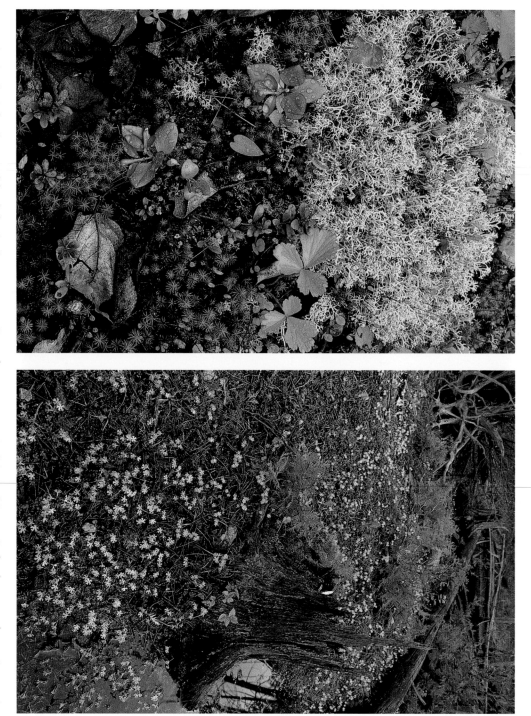

Fringed polygala, Polygala paucifolia (left); bird's-eye primrose, Primula mistassinica (right); wood-betony, Pedicularis canadensis (opposite).

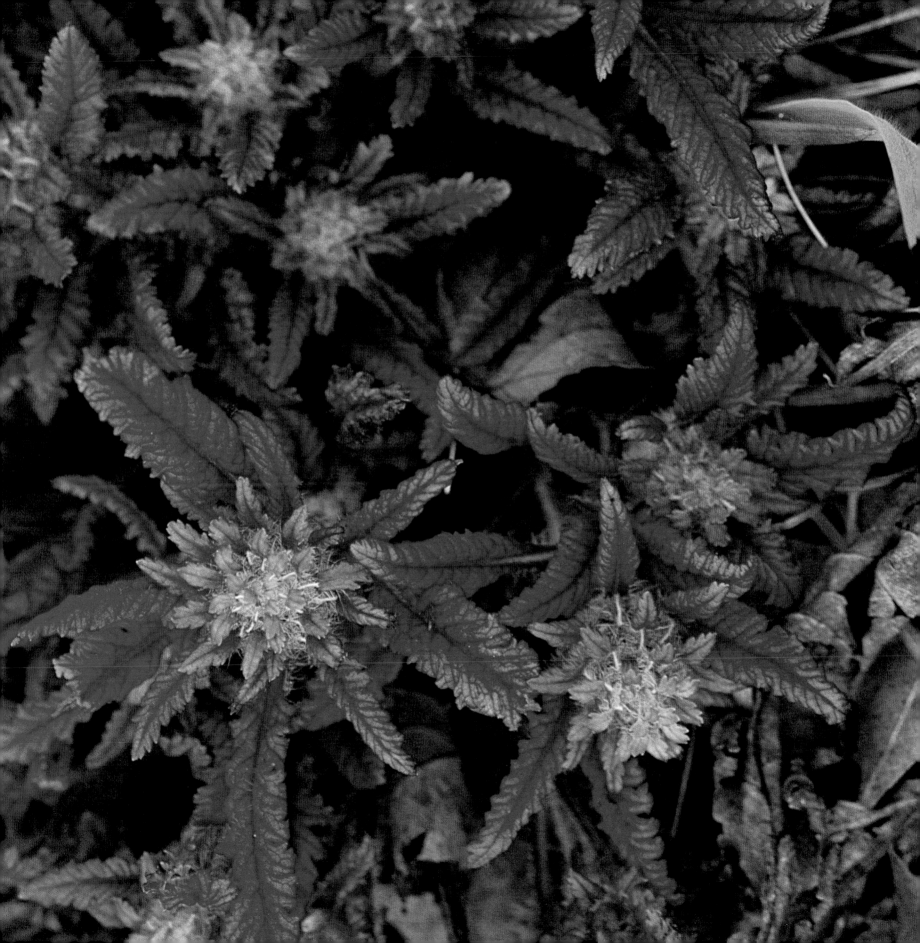

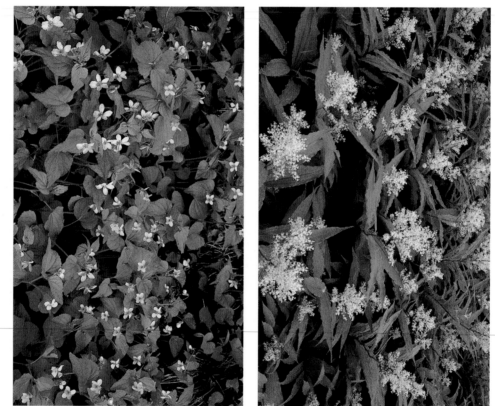

False solomon's-seal, Smilacina racemosa (top); Canada and yellow violets, Viola canadensis and V. pubescens (above); alsike clover Trifolium hybridum, and purple vetch, Vicia cracca (opposite top); bird's-foot trefoil, Lotus corniculatus, ox-eye daisy, Chrysanthemum leucanthemum, and blue-weed, Echium vulgare (opposite bottom).

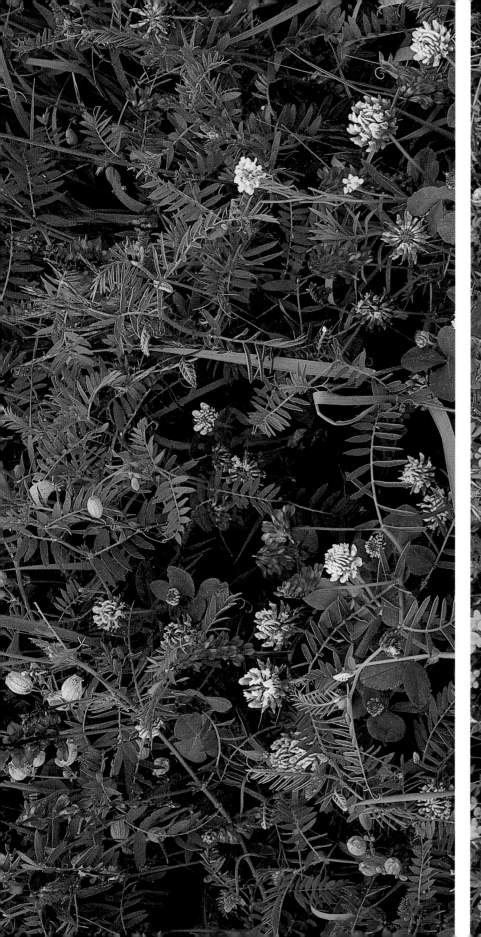
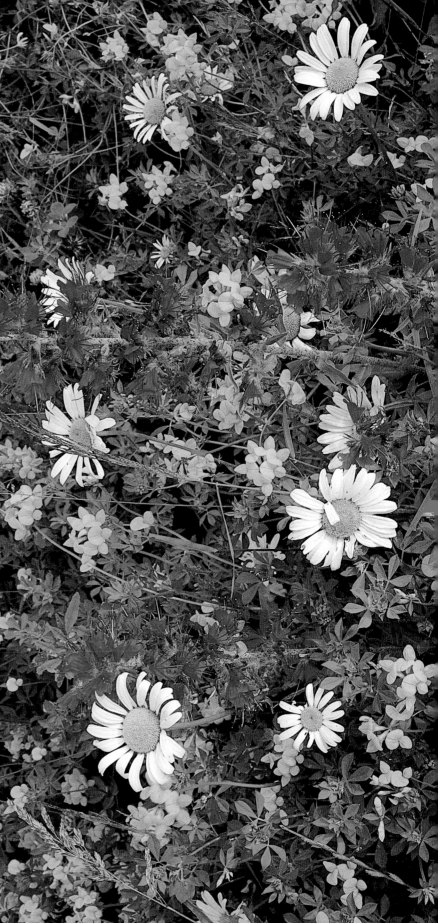

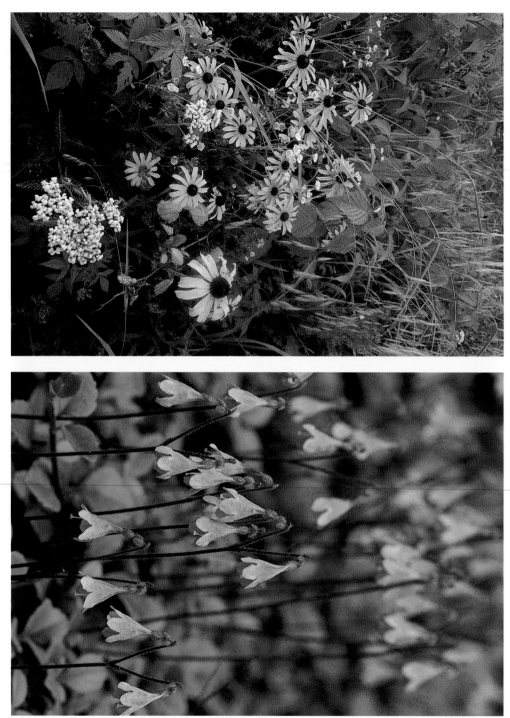

Brown-eyed susan, Rudbeckia hirta, and yarrow, Achillea millefolium (above left); twinflower, Linnaea borealis (above right); rose pogonia, Pogonia ophioglossoides (opposite).

Pickerel-weed, Pontederia cordata (above left); purple loosestrife, Lythrum salicaria, and orange jewelweed, Impatiens capensis (above right); jack-in-the-pulpit, Arisaema triphyllum (opposite).

GLOSSARY

ACHENE: a dry, one-seeded, thin-walled fruit that opens irregularly.

ANTHER: the pollen-producing part of the stamen.

ARIL: an outgrowth or appendage on a seed.

AUTOGAMY: self-pollination.

BALLISTIC EJECTION: the forcible ejection of seeds from the capsules.

BRACT: a scale- or sheathlike modified leaf.

CLEISTOGAMOUS FLOWER: a flower that does not open, yet sets seed.

COLUMN: the central structure of orchids, which contains the sexual organs.

DICHOGAMY: appearance of male and female structures at different times on the same flower.

DIOECIOUS: bearing male and female structures on separate plants.

DISK FLOWERS: the central tubelike bisexual flowers on a member of the Compositae family.

DISTYLY: possessing two different forms of styles.

ELAIOSOME: a fleshy outgrowth on a seed, frequently attractive to ants.

ENDOMYCORRHIZAL: a mycorrhizal association that enters plant root cells.

EPHEMERAL: lasting for only a brief period.

FILAMENT: the slender part of the stamen that supports the anther.

FLOWER: the floral structure that contains the sexual parts, petals, and sepals.

FLOWERHEAD: a tight arrangement of tiny flowers into a central structure resembling a single flower.

HETEROSTYLY: possessing styles of varying lengths.

INFLORESCENCE: a cluster of flowers on a single plant.

MYCORRHIZAL ASSOCIATION: a symbiotic association between the roots of a plant and a fungus.

NECTAR: a sugar-containing liquid secretion.

NECTAR GUIDE: a pattern that directs pollinators to the nectar.

NECTARY: the structure that secretes nectar.

OVARY: the part of the pistil that contains the eggs.

PAPPUS: an outgrowth of hairs, scales, or bristles on the achene (seed) of a member of the family Compositae; used for wind dispersal.

PETAL: one of the inner set of leaflike structures, frequently brightly colored, which surrounds the sexual structures.

PISTIL: the central female structure, typically consisting of ovary, style, and stigma.

POLLEN: the capsules bearing the male sex cells.

POLLEN TUBE: the tube that grows from a pollen grain into the pistil.

PHOTOSYNTHESIS: the manufacturing of carbohydrates using the energy of light.

POLLINATION: the transfer of pollen from an anther to a stigma.

POLLINIA: a mass of sticky pollen, typically produced by orchids.

PROBOSCIS: the tubular mouthpart of an insect.

PUBESCENT: possessing numerous small hairs.

RACEME: an unbranched elongate flower cluster in which the lower flowers open first.

RAY: a straplike petal or group of fused petals bearing a single flower.

RHIZOME: an underground stem.

SAPROPHYTE: a plant that gets nutrition from decaying organic matter.

SEPALS: the outermost part of a flower, consisting of modified leaves.

SPECIES: a single type of organism.

SPIKE: an elongate inflorescence in which the flowers lack stems.

STAMEN: the male structure containing an anther and a filament.

STAMINODE: a sterile stamen.

STIGMA: the sticky, receptive part of the pistil to which pollen adheres.

STYLE: the slender part of the pistil through which the pollen tube grows.

TENDRIL: special grasping leaflet that aids in climbing.

TRICHOME: a needlelike hook or spike, principally for defense.

TRISTYLY: possessing three different lengths of styles.

UMBEL: a flat-topped flower cluster with all the stalks originating from a common point.

WILDFLOWER: an imprecise term that is loosely applied to selected flowering plants that usually (but not always) have soft stems and conspicuous blooms.

ABOUT THE PHOTOGRAPHS

For the most part, wildflowers are not as elusive subjects to photograph as wild animals. But when it comes to achieving an acceptable photograph, they can be as demanding and frustrating.

Because of a preference for "slower" films (25 and 50 ASA) and for shooting at sunrise, or on overcast days when the light is "soft," slow shutter speeds (in general, one eighth of a second to eight seconds) are unavoidable. During these excrutiatingly long exposures (always accomplished with a tripod), the slightest breeze, raindrops, or insect activity will cause the flower to move. The result is inevitably a blurred image. Consequently, some photographs required more than a couple of hours of attention; others, several days of effort.

In addition to the technical difficulties associated with the art of wildflower photography, other obstacles usually arise in the pursuit of that "perfect" shot. Several of the images in this book were taken in northern regions during the biting fly season (May to July). Painfully vivid memories of nearly unbearable conditions linger.

The photographs were taken with Canon F1 camera bodies and a wide assortment of Canon lenses. The 200-millimeter macro, my favorite wildflower lens, was used for the close-up portraits. Wide-angle lenses, ranging from 20 to 28 millimeters, were used to capture wildflowers in their environment. The extreme close-up photographs involved an autobellows equipped with a close-up lens.

Although I generally do not use filters, for the ultraviolet photographs a Kodak Wrasse 18A filter, which transmits only ultraviolet light, was used in conjunction with black-and-white film. For those who want to dabble in ultraviolet photography, I offer this advice. As this particular filter is a square piece of glass, I modified a Cokin filter holder to attach it to a 100-millimeter macro lens. It does not transmit visible light, so one cannot see through it. You must first set up the camera without the filter in order to see the subject, then very carefully insert the filter. Exposure data were not available, but I discovered by experimenting that there is an eight-stop difference between the actual light meter reading before filter attachment and the setting required after the filter is attached.

A variety of slide films was used for the images, but because of its superb sharpness and natural color renditions, I prefer Kodachrome 25 ASA film. Some of the photographs were taken with Fujichrome Velvia (50 ASA). This film's colors are brighter than Kodachrome's; however I found them to be artificially "pumped up" and I prefer Kodak's greens. Kodak generously provided me with some of its new (at the time unavailable on the Canadian market) Lumiere 100X (100 ASA) slide film. I was extremely impressed by its sharpness and rich color saturation. This promises to be an important film for all outdoor photographers.

Every effort was made to record a wildflower in its natural setting, with virtually no manipulation on my part. Consequently, plants were never sprayed for that "wet" effect. Water droplets on the flowers in this book were always a result of rainfalls or heavy dew. Natural light was used for all but a couple of images.

We are privileged to have an abundance of wildflowers to enjoy. When we are concentrating on one individual, however, it is extremely easy to damage other nearby plants accidentally. It is everyone's responsibility to ensure that our enjoyment of wildflowers does not, in even the slightest way, result in damage to the plants or to degradation of their natural habitat.

ADDITIONAL READING

Rather than attempt to compile an in-depth summary of all the literature available on wildflowers (which would be a most formidable task), only a few specific books are listed here. The excellent reference lists in the more recent publications will lead the enthused reader further into the wealth of wildflower literature.

Allen, M.F. *The Ecology of Mycorrhizae*. Cambridge University Press, 1991.

Barth, F.G. *Insects and Flowers*. Princeton University Press, 1985.

Darwin, C. *The various contrivances by which orchids are fertilised by insects*. John Murray, 1877.

Doust, J.L. and L.L. Doust (eds.). *Plant Reproductive Ecology*. Oxford University Press, 1988.

Dressler, R.L. *The Orchids*. Harvard University Press, 1981.

Faegri, K. and L. van der Pijl. *Principles of Pollination Ecology*. Permagon Press Ltd., 1971.

Faulkner, H.W. *The Mysteries of the Flowers*. Frederick A. Stokes Company, 1917.

Harborne, J.B. *Introduction to Ecological Biochemistry*. Academic Press, 1988.

Howe, H.F. and L.C. Westley. *Ecological Relationships of Plants and Animals*. Oxford University Press, 1988.

Proctor, M. and P. Yeo. *The Pollination of Flowers*. Collins, 1973.

Real, L. (ed.) *Pollination Biology*. Academic Press, 1983.

Schnell, D.E. *Carnivorous Plants of the United States and Canada*. John F. Blair, 1976.

Stokes, D.W. and L.Q. Stokes. *A Guide to Enjoying Wildflowers*. Little, Brown and Company, 1985.

Storm on the Desert

Storm on the Desert

WRITTEN BY Carolyn Lesser

ILLUSTRATED BY Ted Rand

Harcourt Brace & Company

San Diego New York London

Printed in Singapore

In the pale light of dawn
A shaggy tarantula tiptoes
To her burrow.
Crush, crush,
Whisper her footsteps
On the cool, fragile earth.

A shadow slinks
From a thicket of mesquite.
The coyote stretches and howls
To the wisp of a moon.
He trots, looking for water,
But finds only cracked earth.
He sits.
He waits.

A cactus wren's raucous call
Awakens the desert.
Startled bats swoosh into caves.
Scorpions scuttle under sticks.
The sun rises,
Casting gigantic saguaro shadows
Across the warming earth.
A tortoise, big as a boulder,
Lurches over the gritty ground,
Searching for juicy plants.
But everything is dry as dust.

Sun burns the crackly earth.
Flickers and elf owls
Tuck into holes in saguaros.
Jackrabbits rocket to shady shrubs,
Their feet barely touching the sizzling soil.
Lizards run on their toes, tails in the air.
The tortoise burrows deep into coolness
And settles.
As columns of heat rise, shimmer,
The coyote curls under the mesquite,
Becoming a shadow.
High above,
In the endless blue,
A vulture drifts.

Silence wanders
Through ironwood trees and cactus,
Slips over beetles and red velvet-ants,
Past butterflies resting on branches.
It fills the tortoise tunnel.
Shh, shh,
Whispers the scorching breeze.
The birds are still.
Morning and afternoon,
The desert is the same as yesterday,
As it has been for days and days.

But the sky is not the same.

Soaring high
On a fresh, gusty breeze,
The vulture watches dusky puffs gather.
Clouds roil, churn, tumble.
With a flap
Of his great wings,
The vulture changes direction.

The coyote lifts his head, sniffs,
And sprints from the mesquite
To high ground,
Passing roadrunners
Rushing to thickets
On the darkening hillside.
Elf owls huddle deep in their hollows
As sturdy quail battle the rising wind.

Lightning flashes inside clouds.
Distant thunder growls,
Nears, rumbling between mountains.
Bony fingers of lightning streak,
Strike.
Thunder cracks,
Frightening animals from their burrows.
Foxes and snakes,
Kangaroo rats and squirrels
Race to the highest crevice, bush, or tree.
Winds tear across the ground,
Whip plants back and forth.
Jackrabbits and mule deer
Struggle uphill.
Billows of dust rise from the earth
Like towering giants.
Painted lady butterflies
Clutch life under leaves.
Winds howl.
Brittle branches split,
Snap,
Fly.

Rain shatters the earth.
Dust leaps.
The great bowl of the desert
Fills with lightning and thunder,
Whirling wind,
And sheets of rain.
Plants and animals,
Land and sky
Vanish into rain.
Pelting, piercing,
Slashing, screaming,
Streaming
Rain.

Rivulets run down parched hills,
Across the hard-baked desert floor.
Rivulets become cascades,
Become torrents.
Washes, arroyos, canyons fill up,
Spill over.
The roaring river gathers soil,
Rocks, and plants,
Reaches for animals and insects.
A flood
Falls
From
The
Sky.

Then, as quickly as it began,
The storm quiets,
Lightning an elusive flicker,
Thunder a murmur.
Wind calms.
Downpour slows
To drizzle.
Shafts of sunlight
Stream through clouds.
Drops drip,
Drip,
Drop.

The storm is over.

The breeze is delicious,
With a fragrance like lemons
Coming from the wet bark
Of the creosote bush.
A woodpecker pops out of his hollow
In the saguaro, calling cheerfully,
And the desert echoes with the songs of birds.
The coyote bounds down,
Shaking like a dog after a bath.
He brushes past painted ladies
Crawling to leaf tops,
Fluffing their wings in the sun.
Yesterday the bobcat searched for miles
To find water.
Today he laps from a puddle
Just beyond his cave.
Yesterday the rain pool was cracked earth.
Today the coyote charges forward to drink,
As mule deer, jackrabbits, and kit foxes
Back away
And run from danger.

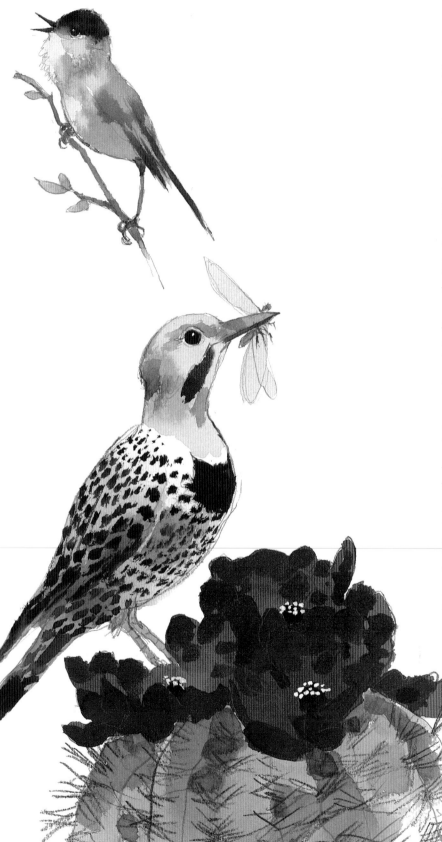

Skinny saguaros and rainbow cactus
Pull in water,
Puff up like prickly pillows.
Sun warms air and soil.
Leaf buds unfurl from bare branches.
Seeds waiting under the ground
Pop open.
Soon the desert will bloom
With summer poppies,
Arizona blue-eyes, rattlesnake weed,
Blackfoot daisies, rain lilies,
And angel trumpets.

Insects that buzz and crawl
And hop and float and fly
Will hover over the blooms, feasting on nectar.
Birds will swoop and soar, catching insects,
Singing with the joy of more food
Than they can eat.
Desert creatures will grow fat.

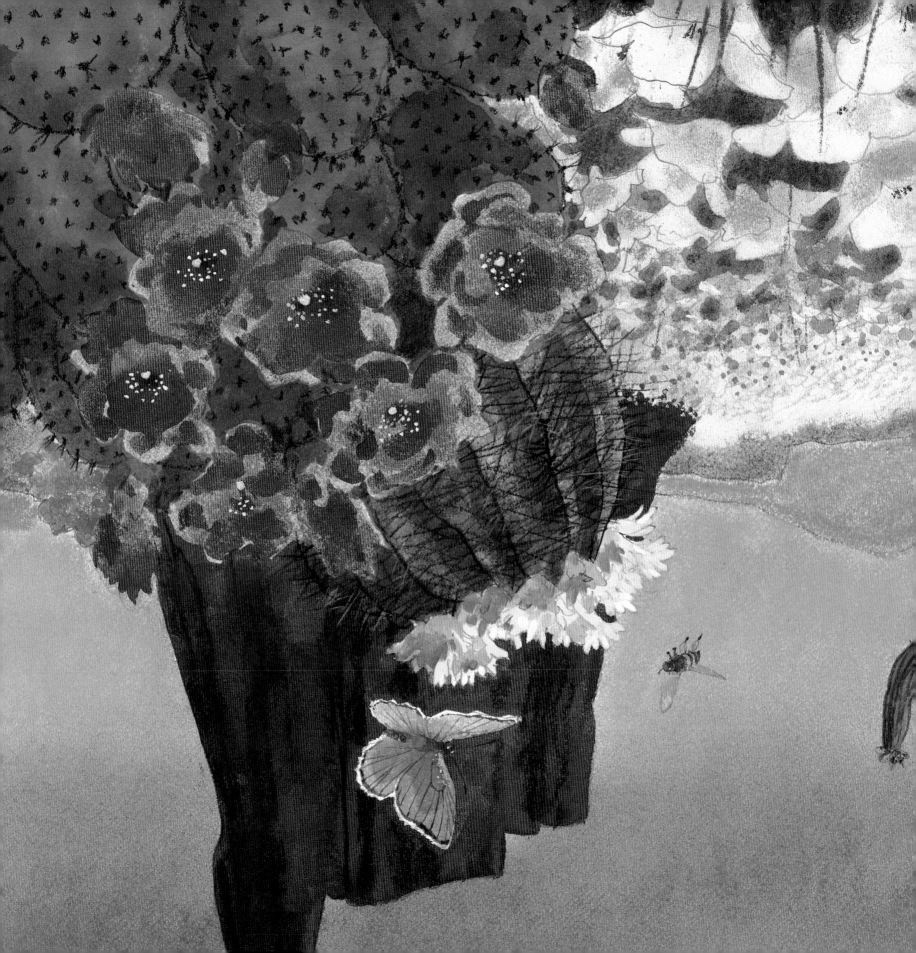

Before long, the sun will heat the desert
Like a dragon breathing fire.
Columns of heat will shimmer,
Drying the soil,
Pushing burning air through cactus spines
And ironwood trees.
Flowers will drop seeds and wither.
Insects will lay eggs and die.
Birds will migrate
Until the next storm.
But on this day,
There is enough of everything
For everyone.

The contented coyote
Slinks under the mesquite,
Becoming a shadow once more.
A warm desert breeze ruffles his fur
As he squints at a vulture
Floating on great, wide wings
High above the desert.

The coyote yawns
And rests his head on his paws.
He waits.
A tarantula tiptoes
Through his shadow.
Crush, crush,
Whisper her footsteps
On the fragile earth.
Hush, hush,
Swirls the sunset breeze.
In the cooling desert stillness,
Before tonight's hunt,
The coyote closes his eyes
And sleeps.

For Jeannette Larson, editor and friend,
whose vision of the storm and patience with the process
made the path appear. Thank you.

—C. L.

For the staff and volunteers
at The Living Desert in Palm Desert, California.

—T. R.

Requests for permission to make copies of any part of the work
should be mailed to: Permissions Department, Harcourt Brace & Company,
6277 Sea Harbor Drive, Orlando, Florida 32887-6777.

Library of Congress Cataloging-in-Publication Data
Lesser, Carolyn.
Storm on the desert/written by Carolyn Lesser; illustrated by Ted Rand.—1st ed.
p. cm.
Summary: Describes the animal and plant life in a desert in the American
Southwest and the effects of a short but violent thunderstorm.
ISBN 0-15-272198-3
1. Desert ecology—Southwest, New—Juvenile literature.
2. Deserts—Southwest, New—Juvenile literature.
[1. Deserts—Southwest, New. 2. Desert biology. 3. Thunderstorms.]
I. Rand, Ted, ill. II. Title.
QH104.5.S6L49 1997
574.5´2652´0979—dc20 95-44923

First edition
F E D C B A

The illustrations in this book were done in pencil, pastel, chalk,
and watercolor on 100% rag stock.
The display type was set in Phyllis.
The text type was set in Galliard.
Color separations by Bright Arts, Ltd., Singapore
Printed and bound by Tien Wah Press, Singapore
This book was printed on totally chlorine-free Nymolla Matte Art paper.
Production supervision by Stanley Redfern and Ginger Boyer
Designed by Lydia D'moch

Special thanks to the Lance Stelzleni family, who lovingly
welcomed me to the desert, and to Rich Dulaney and the
wonderful staff of the Arizona-Sonora Desert Museum of
Tucson, Arizona, who showed me the desert with expertise
and enthusiasm, encouraging me to write this book.

—C. L.